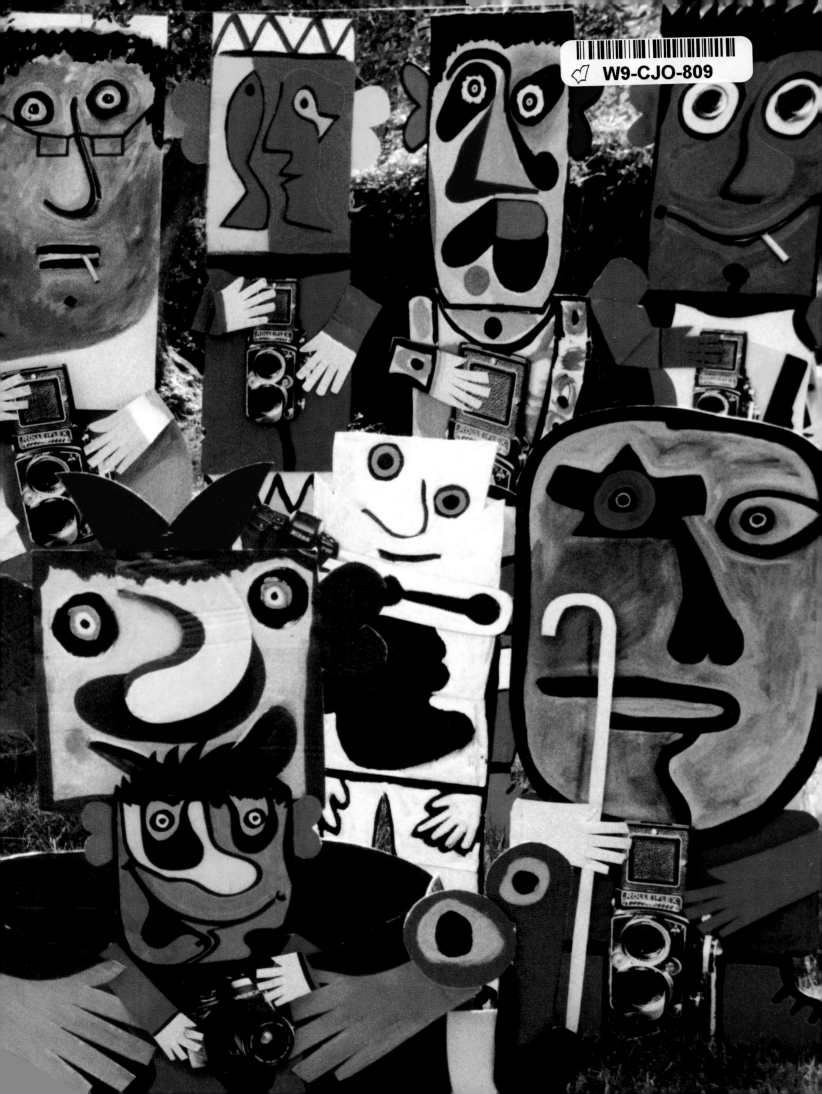

for Jane -

David

a Secret Garden

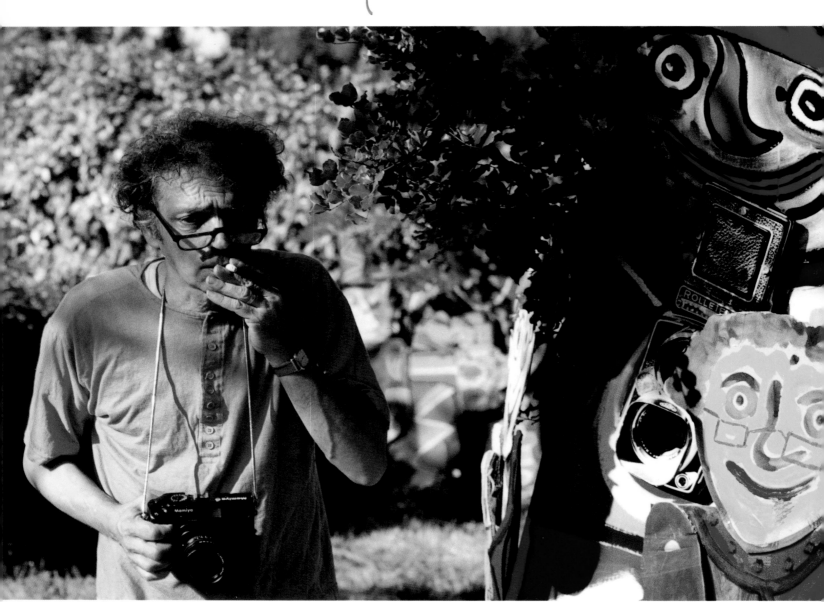

Remembering Moscow, Tokyo, Stockholm and G.G. and John so much more of a shared life

With my Love

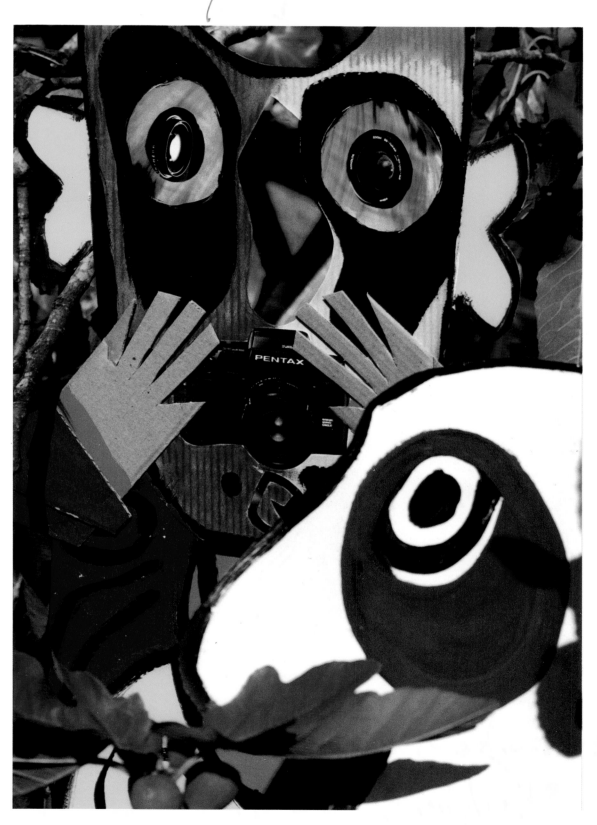

Autumn New York 1992

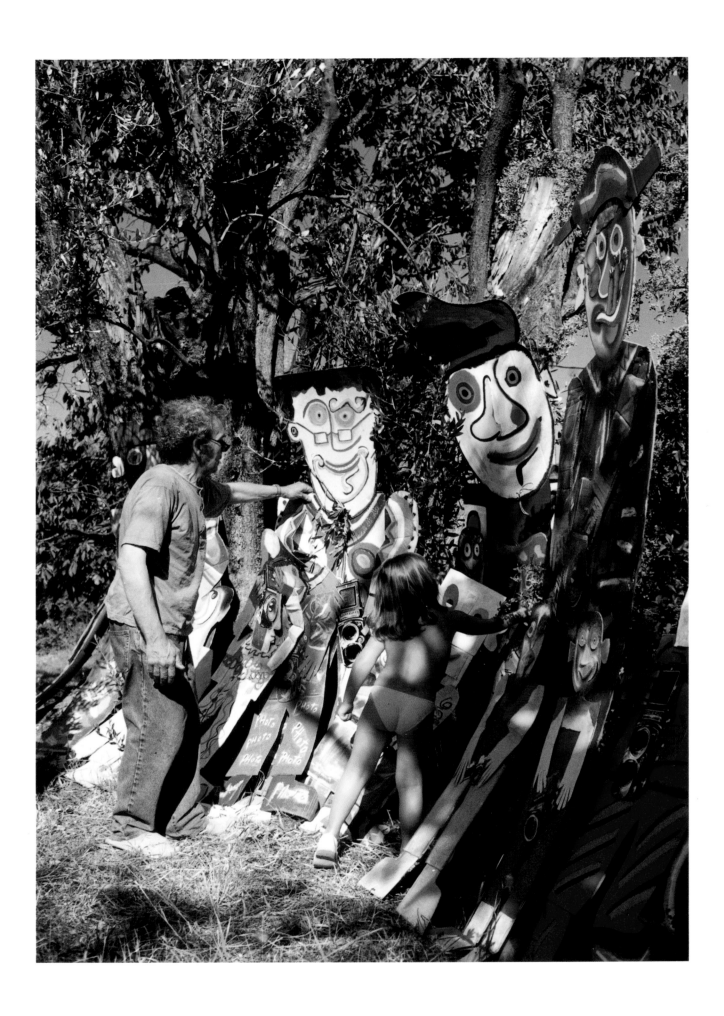

a Secret Garden

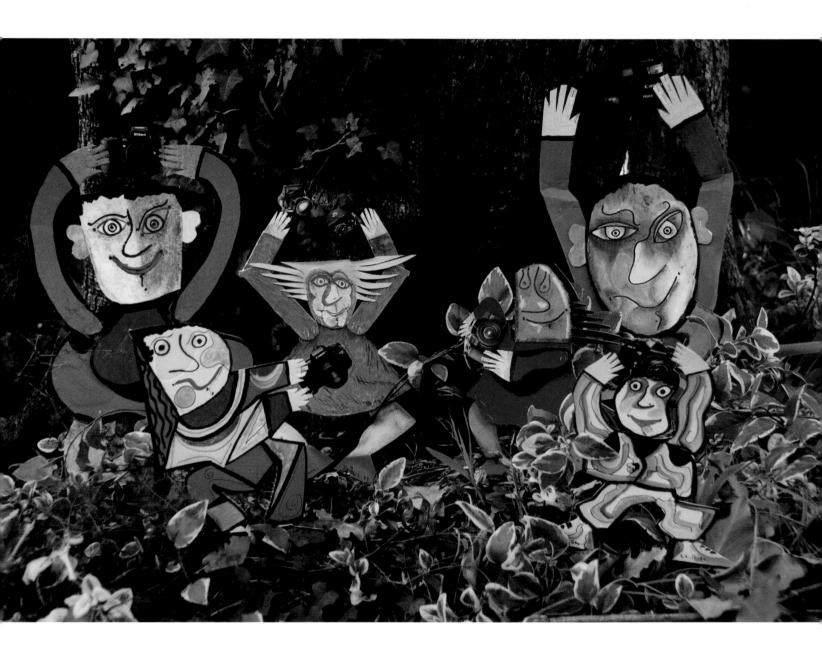

David Douglas Duncan

Publisher

D. D. D.

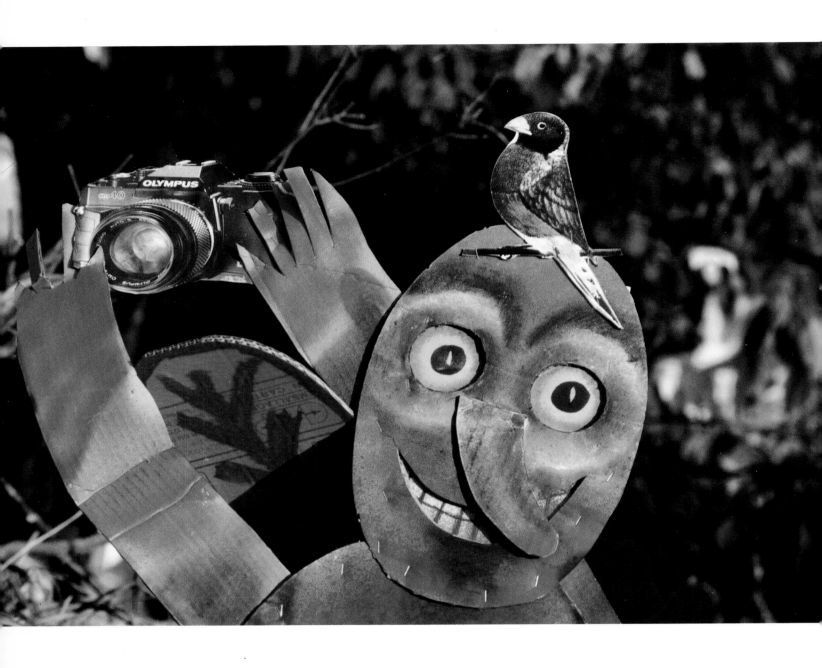

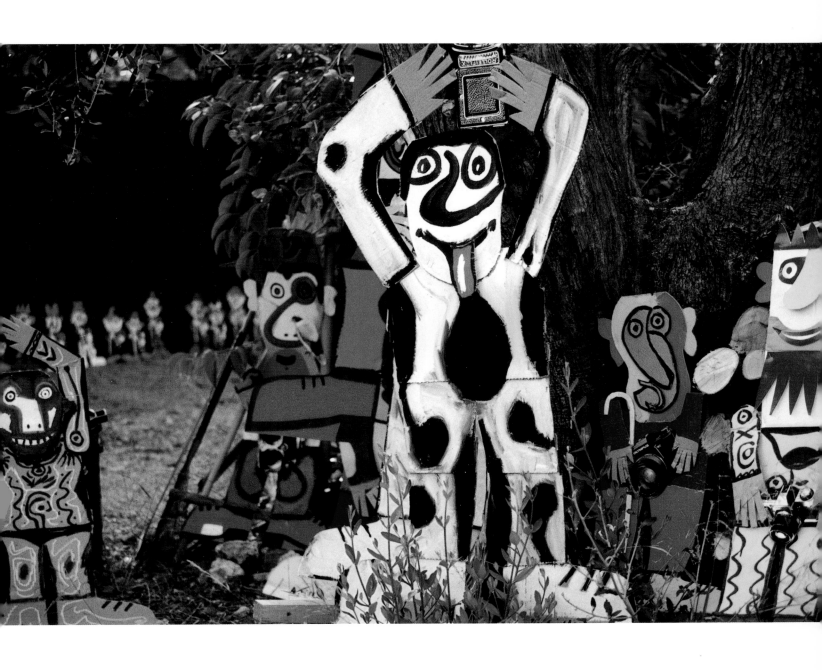

a
Secret Garden
of
Silent Laughter

the Silent Laughter
of
André Villers

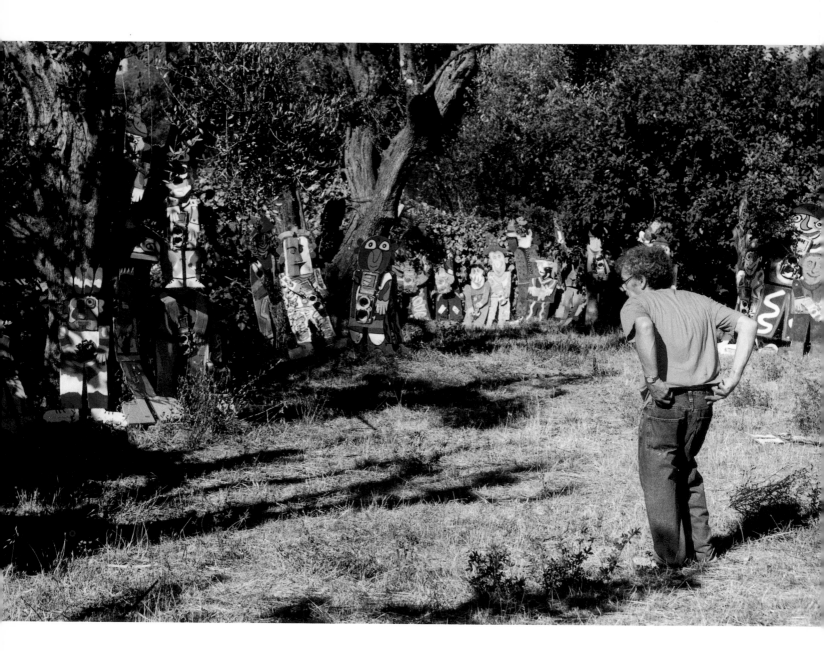

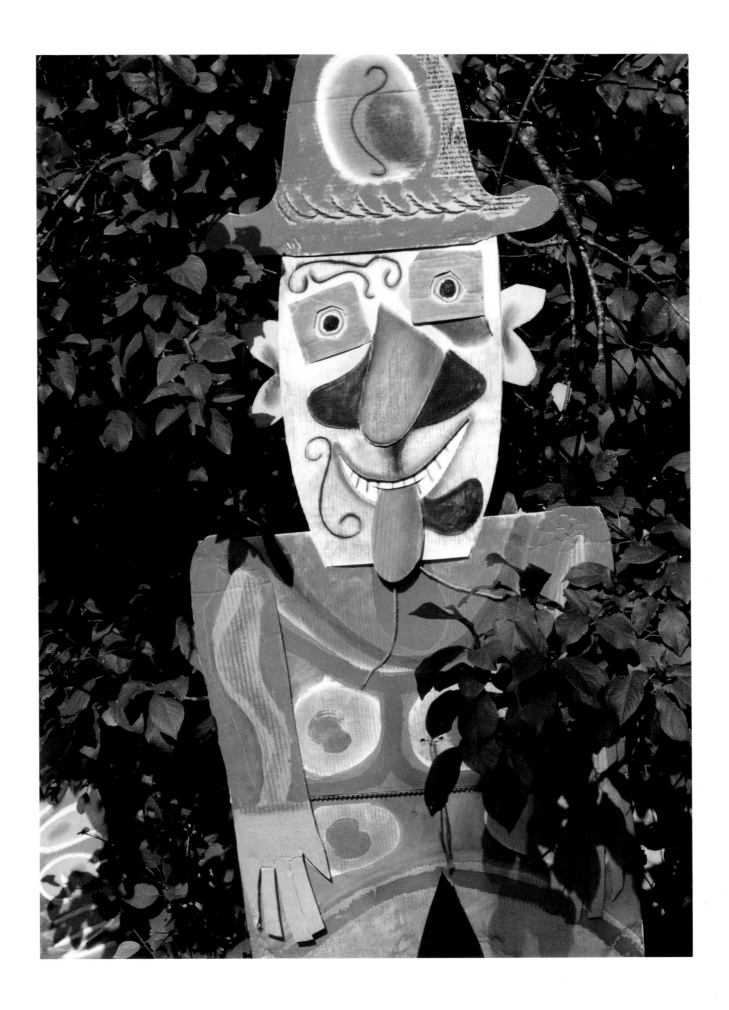

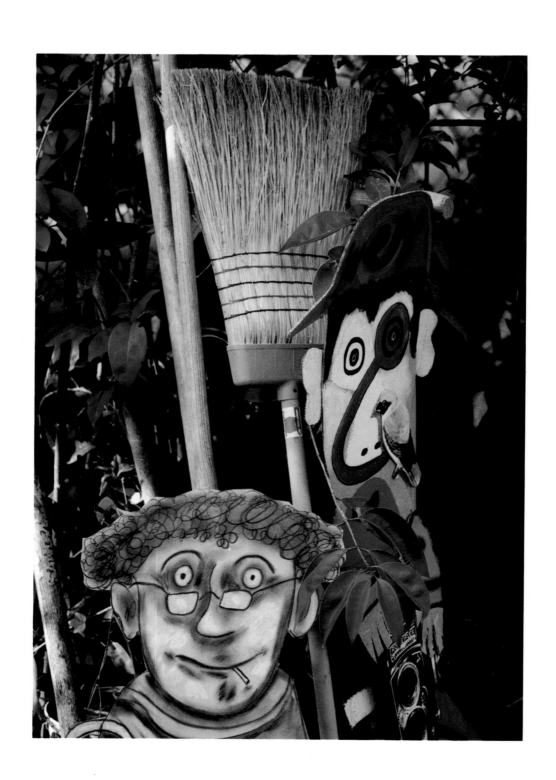

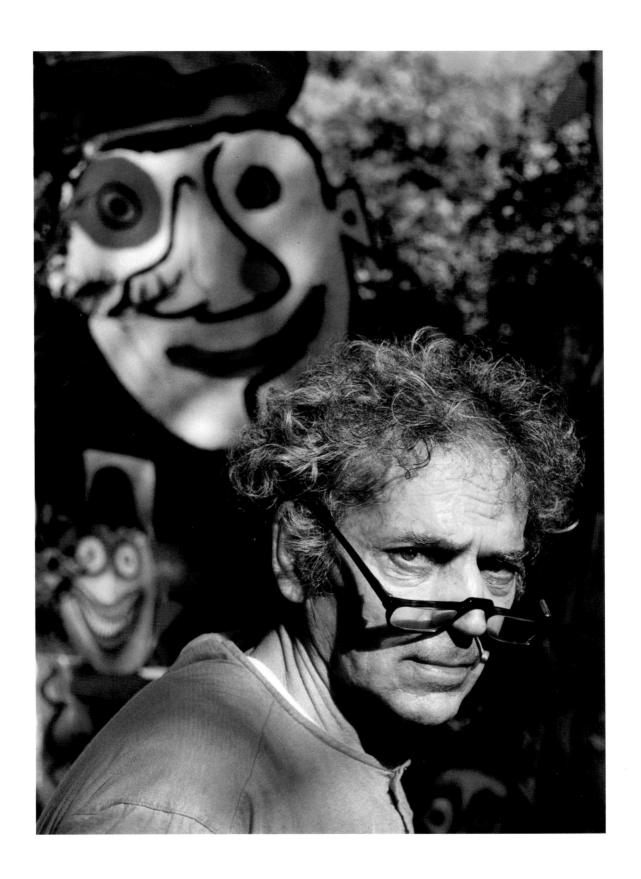

Preface

André Villers must be the funniest man I know and yet I've never heard him laugh.

He just smiles when sharing his hidden Mediterranean garden where he redesigns the world into which he was born. His silent laughter and the camera-crazy inhabitants of his secluded olive and fig grove have recently added a joyous wider dimension to my own world, the memory world of a war photographer who saw life's casualties often strewn at random, with youthful laughter dying, among the first to fall.

A Secret Garden is an attempt to translate some of the humor that I discovered in André's world into newborn laughter for anyone seeking relief from the steadily rising flood of tragic images of disaster victims which seem about to engulf our troubled Earth.

Villers taught himself everything he treasures most in life: photography, painting, a passion for poetry -- and how to walk once again after five claustrophobic years spent in plastercasts when many doctors dismissed him as a hopeless invalid. He had earlier been stricken with a spinal deformity caused by wartime childhood malnutrition during enemy occupation of his hometown in eastern France. After the Allied victory his life was restricted to a hospital bed, totally immobile, in sunny Vallauris on the Côte d'Azur. He was later loaned an ancient camera as part of the therapy to make him walk again. During one of his first labored struggles through the back lanes of Vallauris he was noticed by another new resident of the ceramics village -- Pablo Picasso. The renowned artist suggested that the work he was doing in nearby pottery kilns could make interesting photographs, which might be saleable someplace. He also gave the excruciatingly timid young man a new Rolleiflex camera and his friendship to the end of his life. André's fate had been reborn.

Today, a master photographer, his portraits of painters and poets have been honored and published internationally for thirty years. We have been friends even longer, having first met at Picasso's French Riviera studio-home in 1957. During all of these years I've known André only as an extraordinarily sensitive and shy colleague who never revealed any talent other than that of fine photography.

Unheralded and unpublished for the last seven years, while shooting portraits of the most celebrated and obscure artists, Villers has also isolated himself in a one-room homemade shack next to the darkroom in his garden. Soundless eruptions of his imagination now threaten to bury him there. Each day two, three, five -- once seven -- hilarious, mysterious, and great haunting characters of sculpted cardboard appear at his side. And numerous self-portraits, not one of them self-pitying.

Hundreds upon hundreds are stacked in that almost exploding hideaway, all concealed behind his garden wall. Sometimes friends and their children spend hours carrying everything out under the trees so that André might see his work gathered around him. Then the elfin parade returns. By midnight all are back in their shack protected from rain and mistral wind.

Each is different. All reveal some frailty of our human condition. All have been touched by the brush of a natural-born colorist and fired by that elusive spark which brings life to inanimate material. Prehistoric artists molded clumps of common clay and carved exotic stones into folkloric images and the gods of their time which today often still glow with the flame of their creators' fantasy. Many of Villers' creations possess that same refined simplicity and power: a new folk art of our time. For each is embellished with a shining symbol of our hi-tech mini-religion, the now worldwide cult-of-the-camera. André's olive and fig trees seem to be sheltering both a Garden of Eden and another Noah's Ark overflowing with fanatic amateur photographers -- even naked little Adam himself wandering around uncertain where to focus (*page 53*), blissfully unaware of the outrage of those nearby more conservative camera club members.

Working with only a razor-knife and discarded boxes brought home by his wife from the nearby supermarket, an office stapling machine and his seemingly never exhausted imagination, Villers is creating the entire population of a mythical race -- a children's world of giants and gnomes for everyone.

He has also captured with ordinary corrugated board and often subtle colors many of the fleeting expressions that gave challenge and meaning to my own life behind cameras while searching for faces in the pageant of yesterday, which was my century.

The tale being told -- without words -- in André's garden is another of those unknown fragments of the endless human fable that is all of us, every day.

D.D.D.

New Year's morning 1992
Castellaras-le-Vieux
France

Discovering Another World of

Giants Gnomes

and

Photographers

of the

Imagination

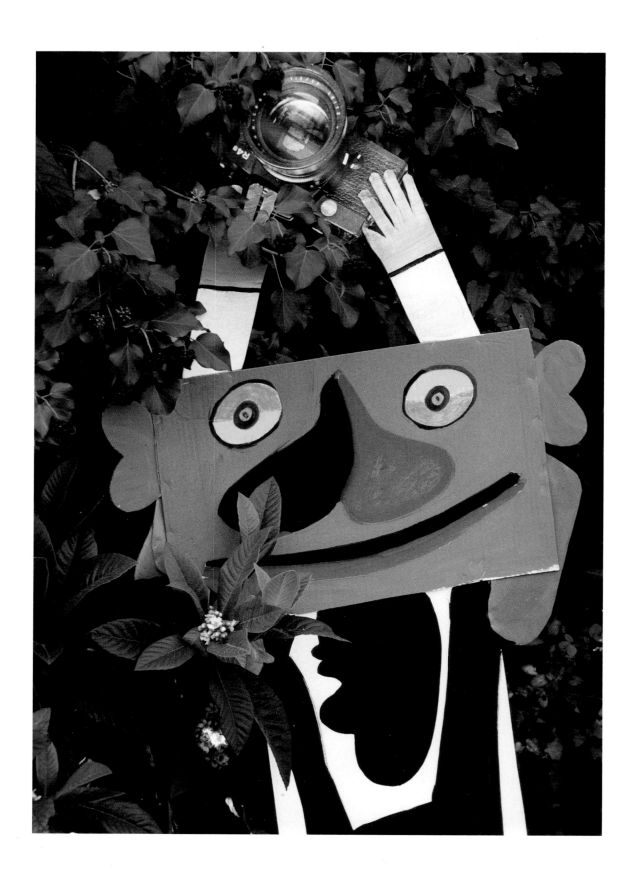

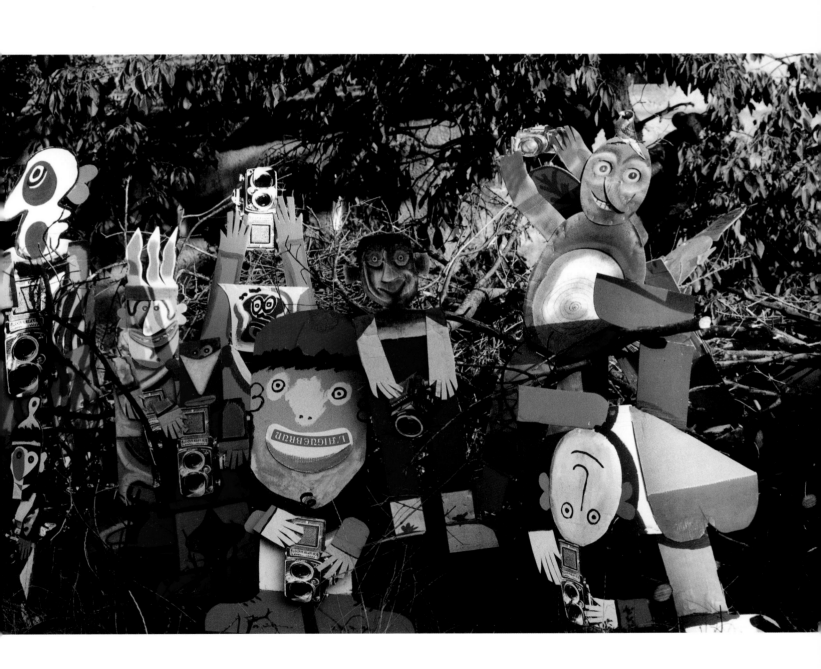

André's Secret Garden

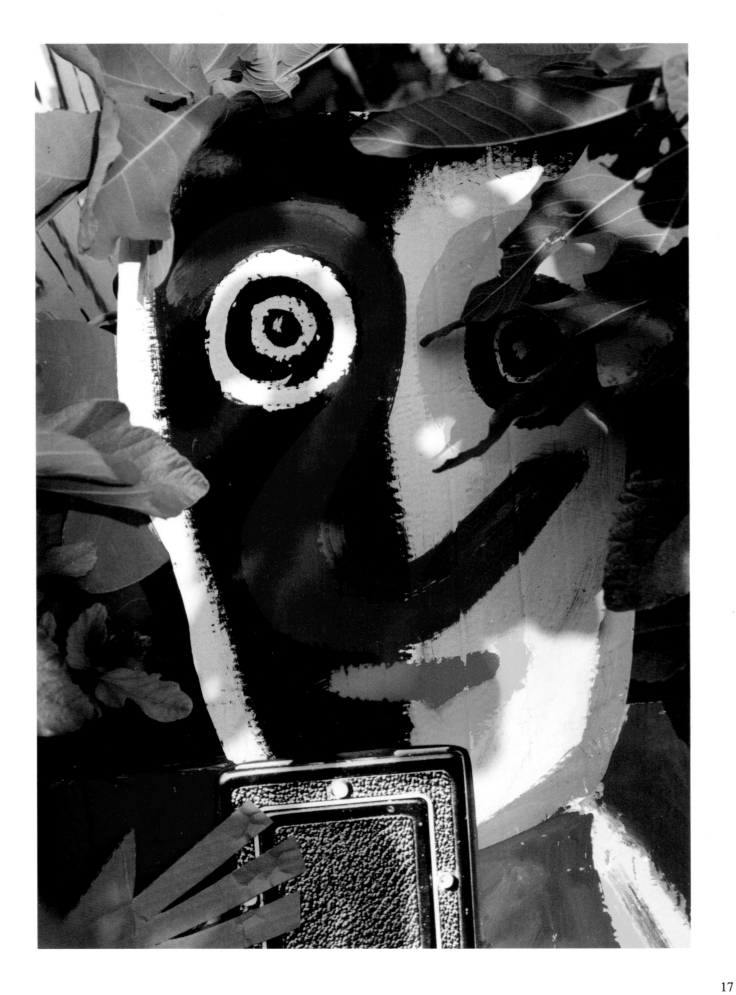

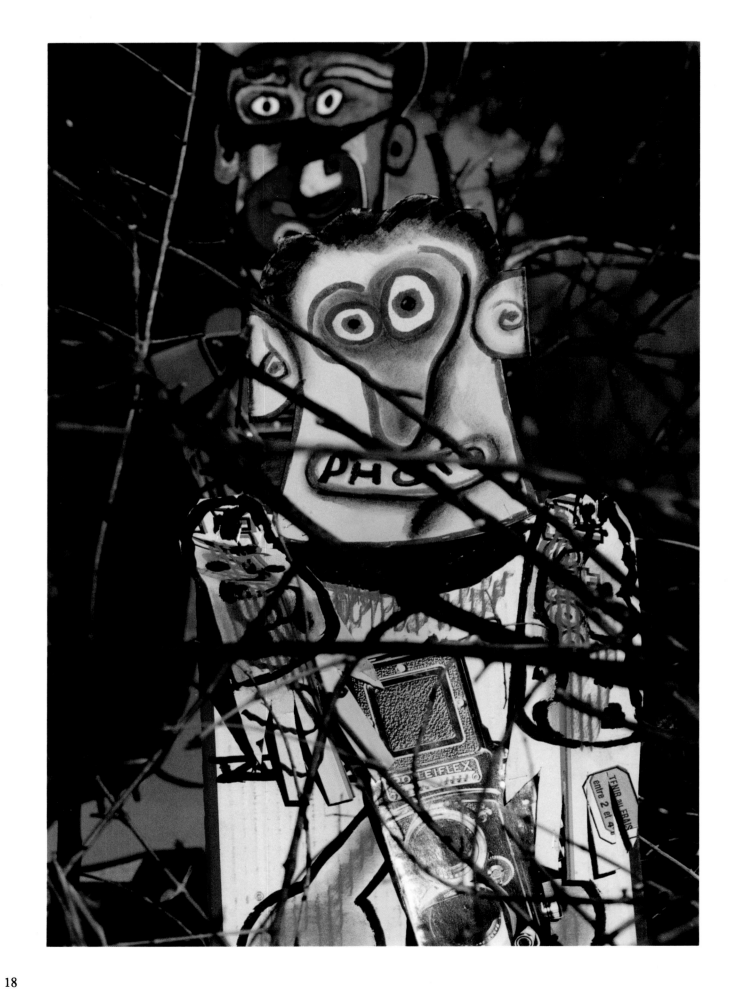

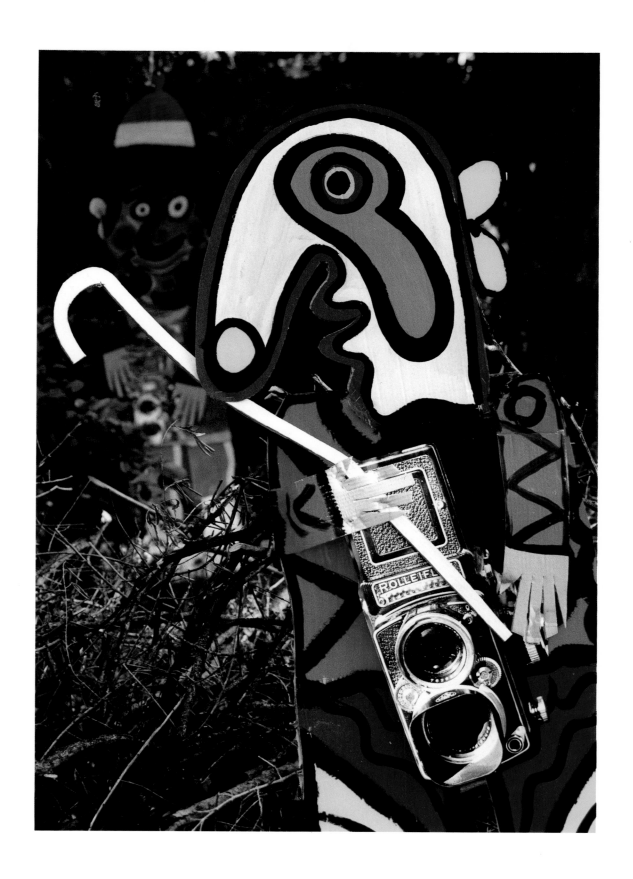

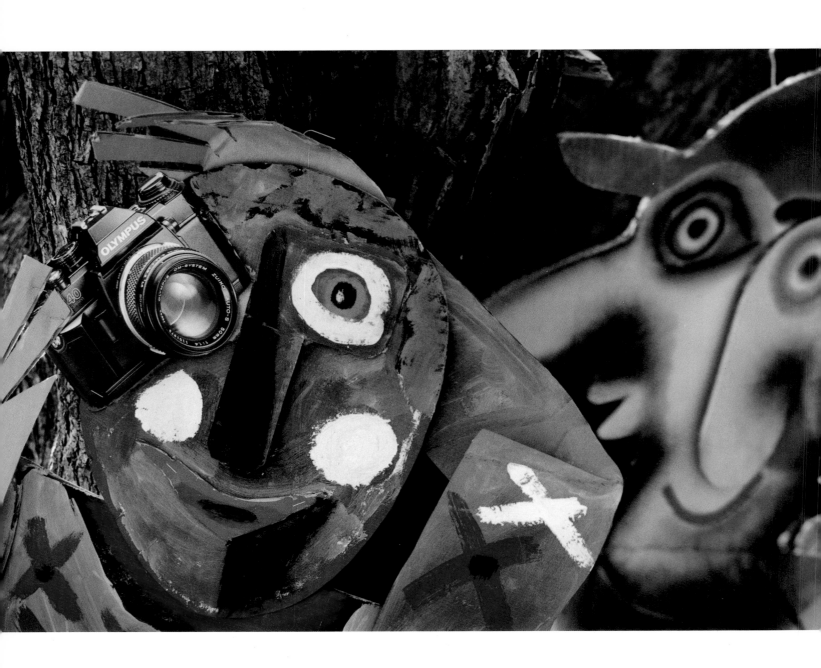

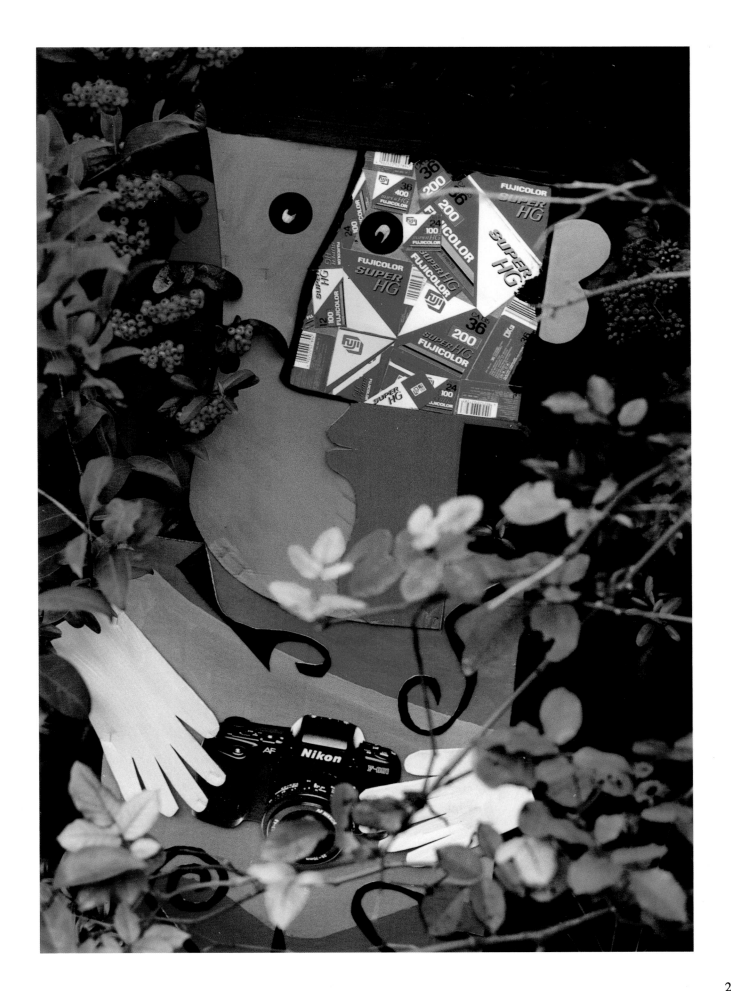

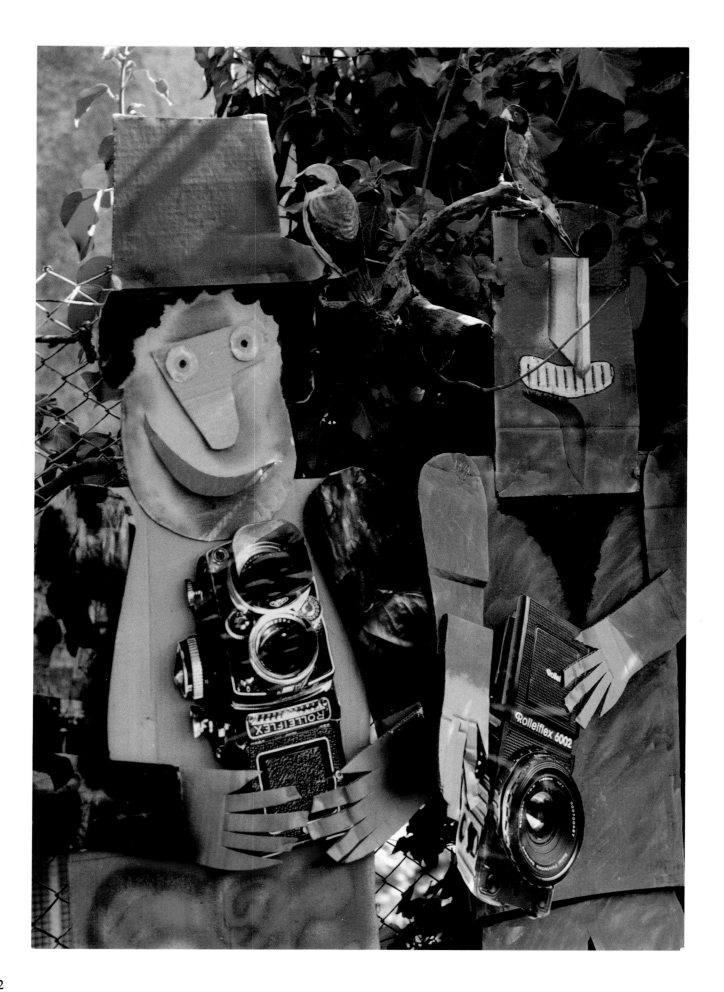

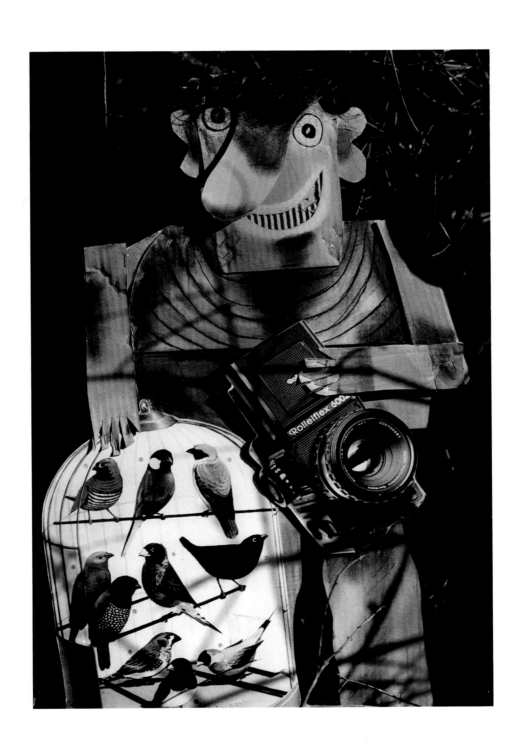

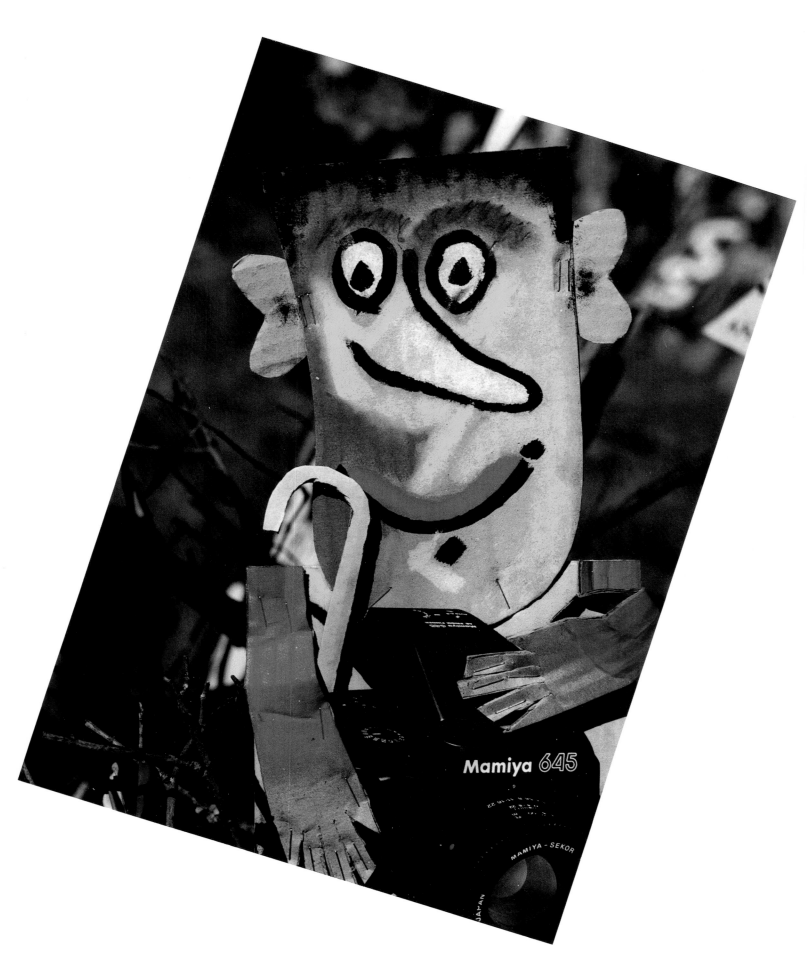

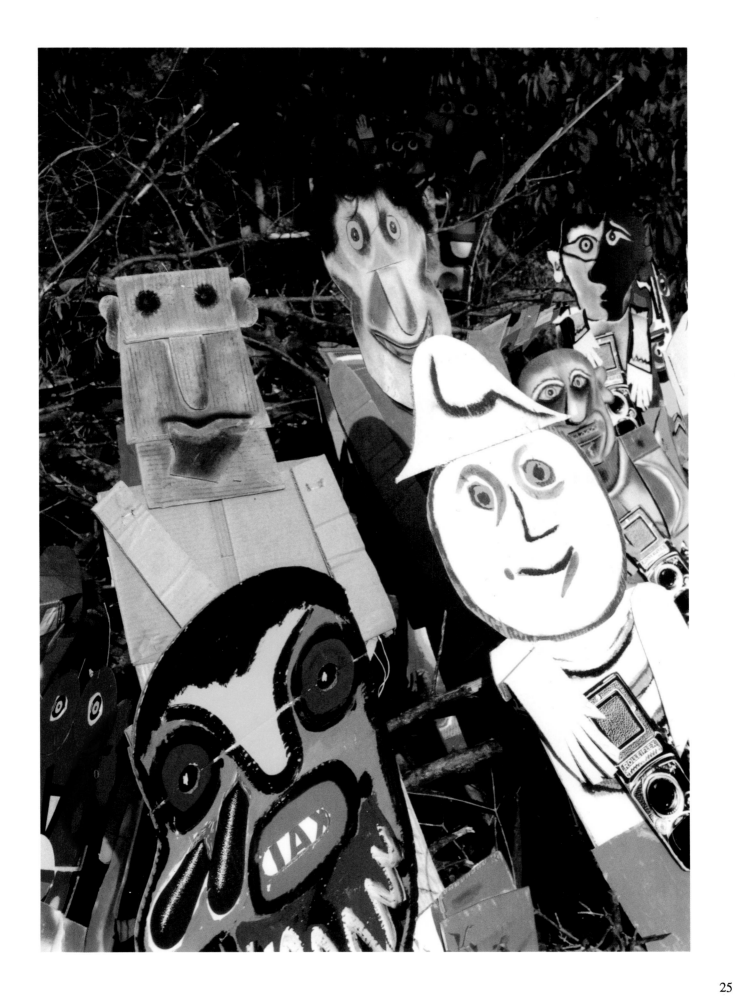

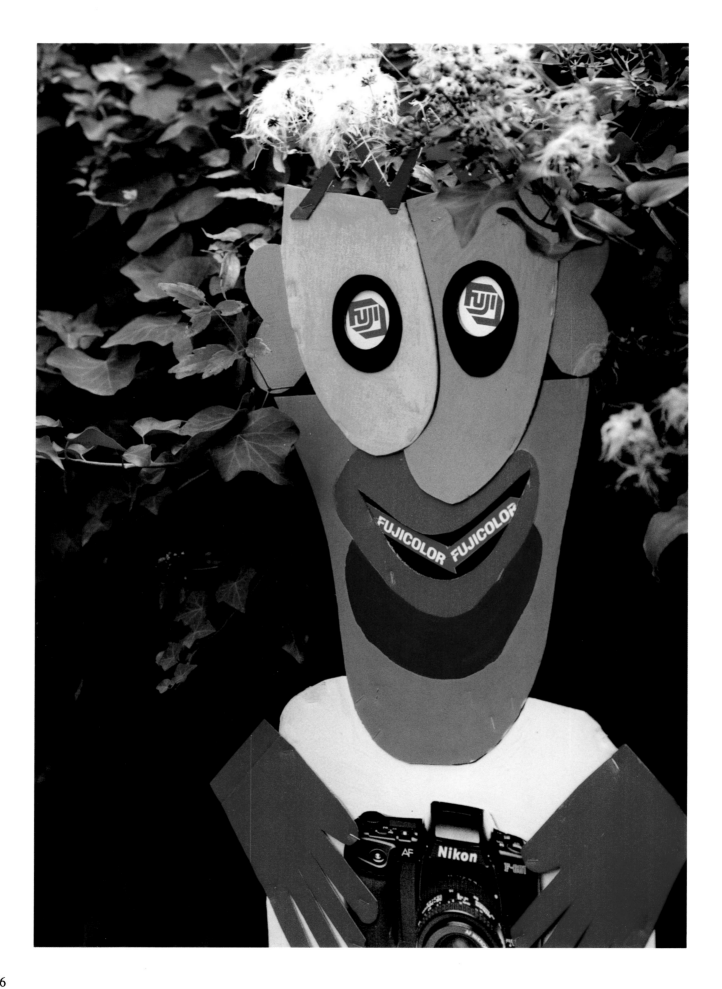

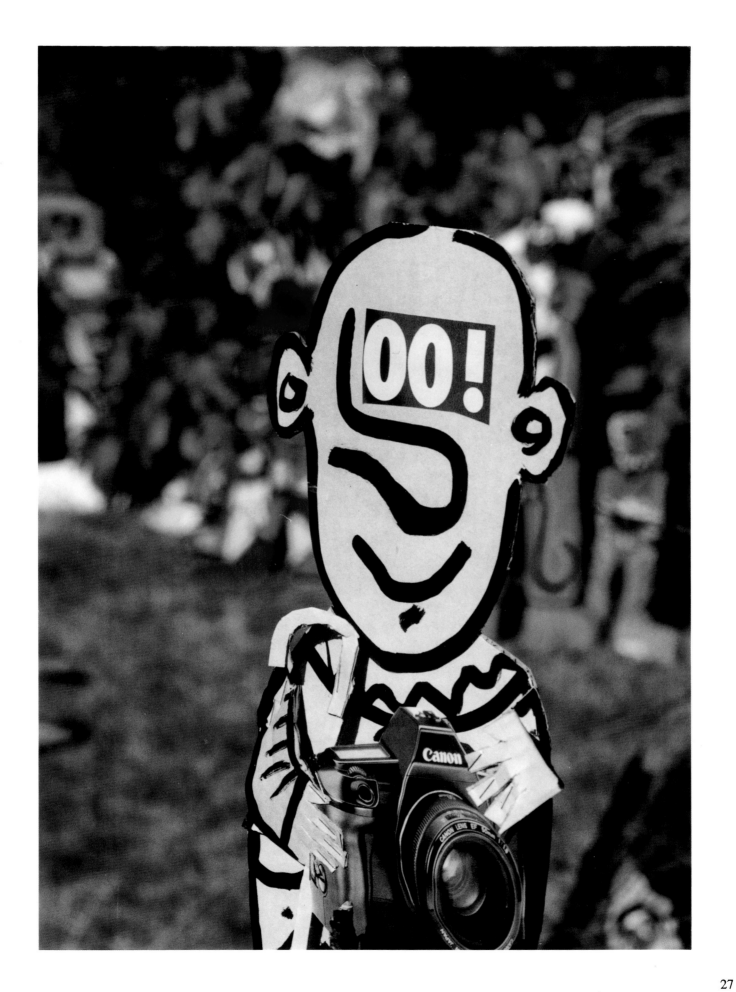

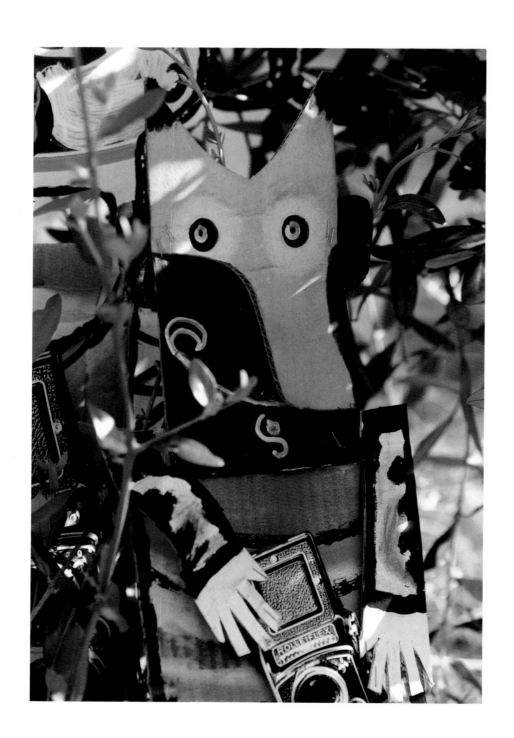

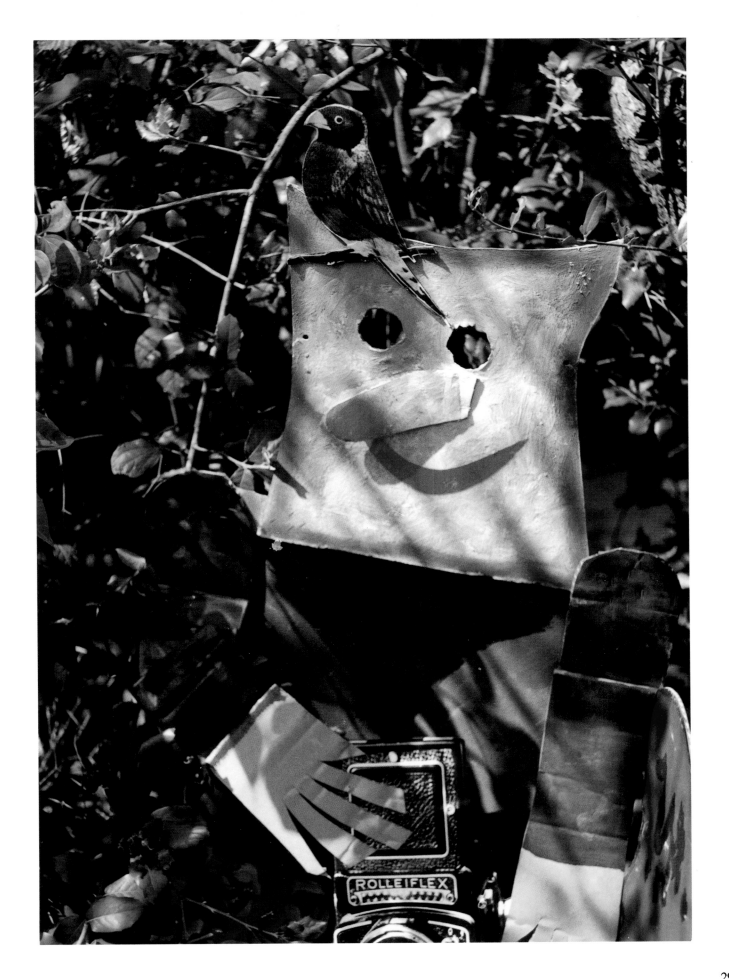

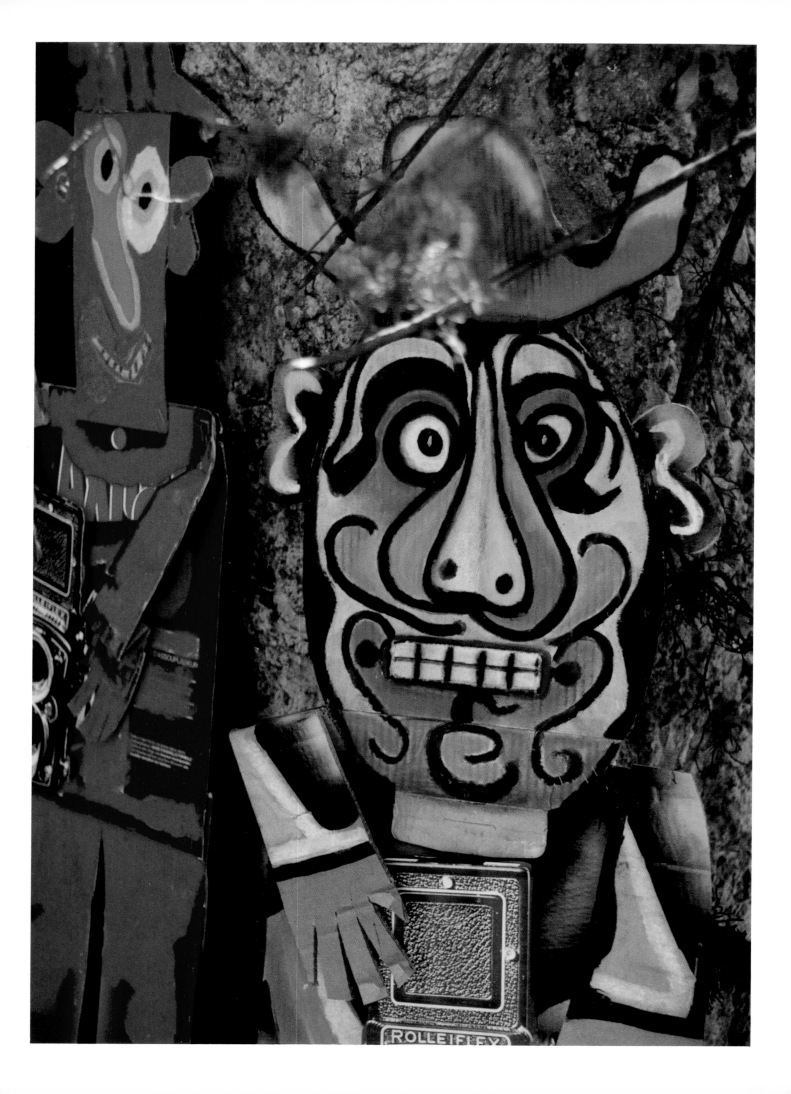

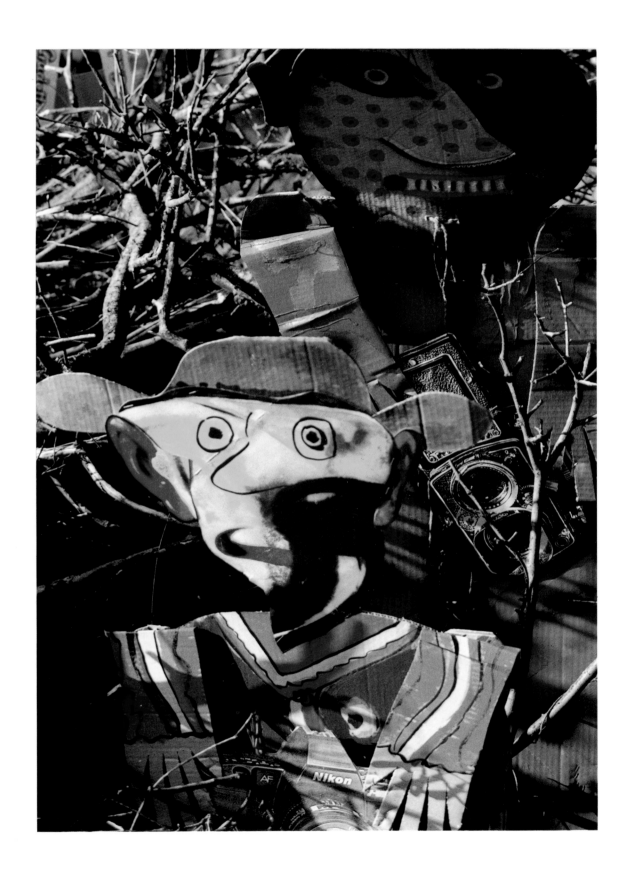

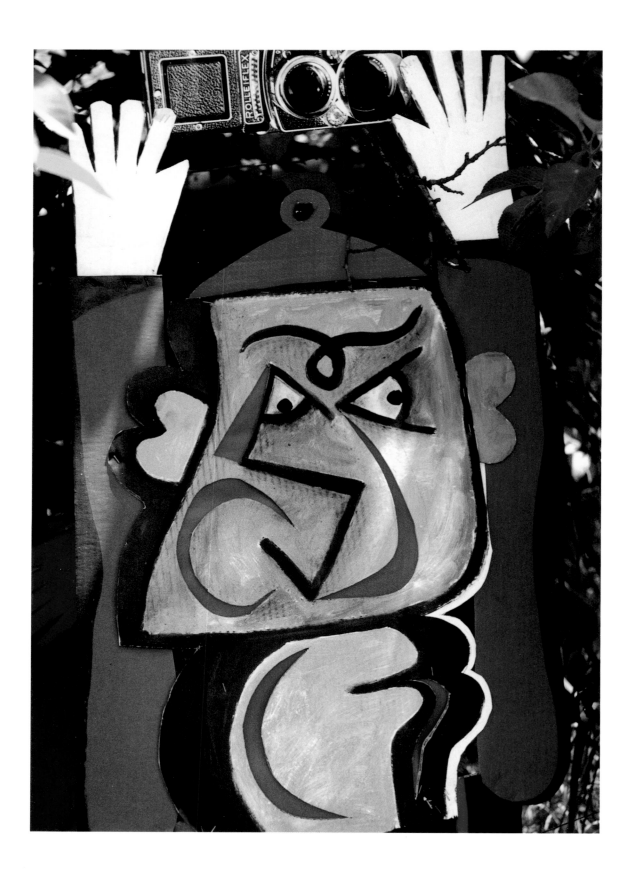

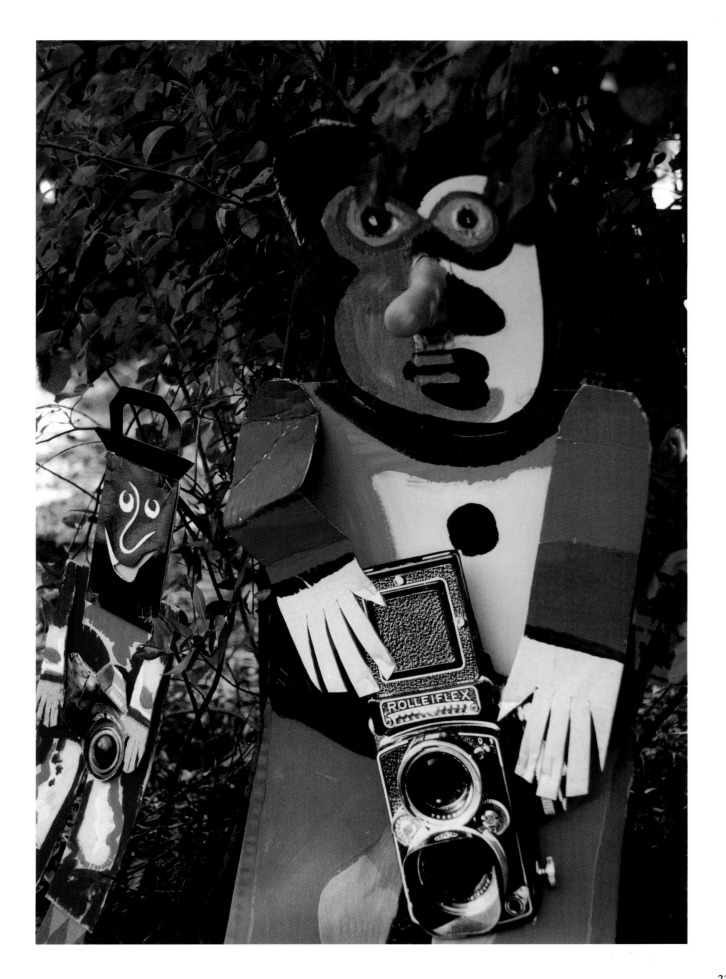

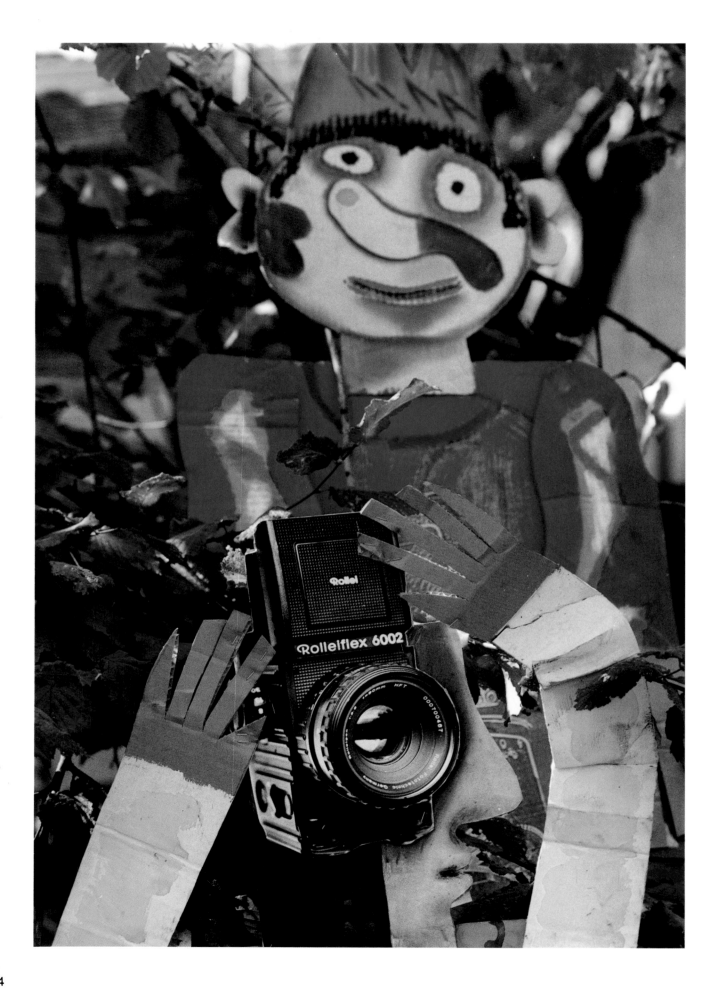

34

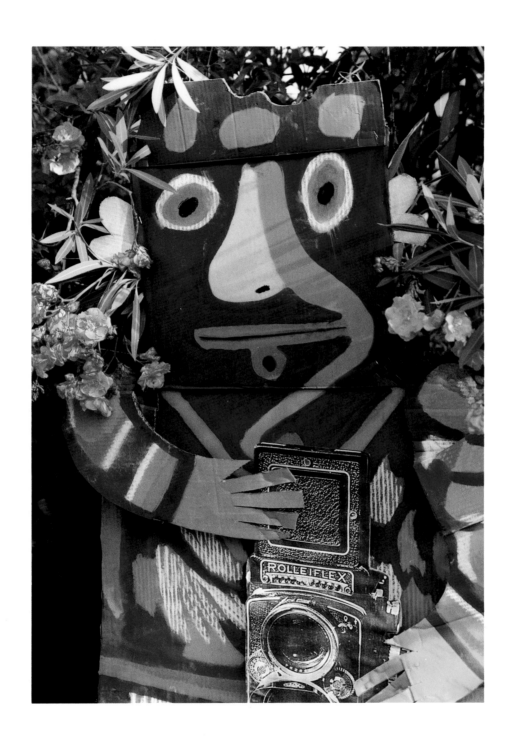

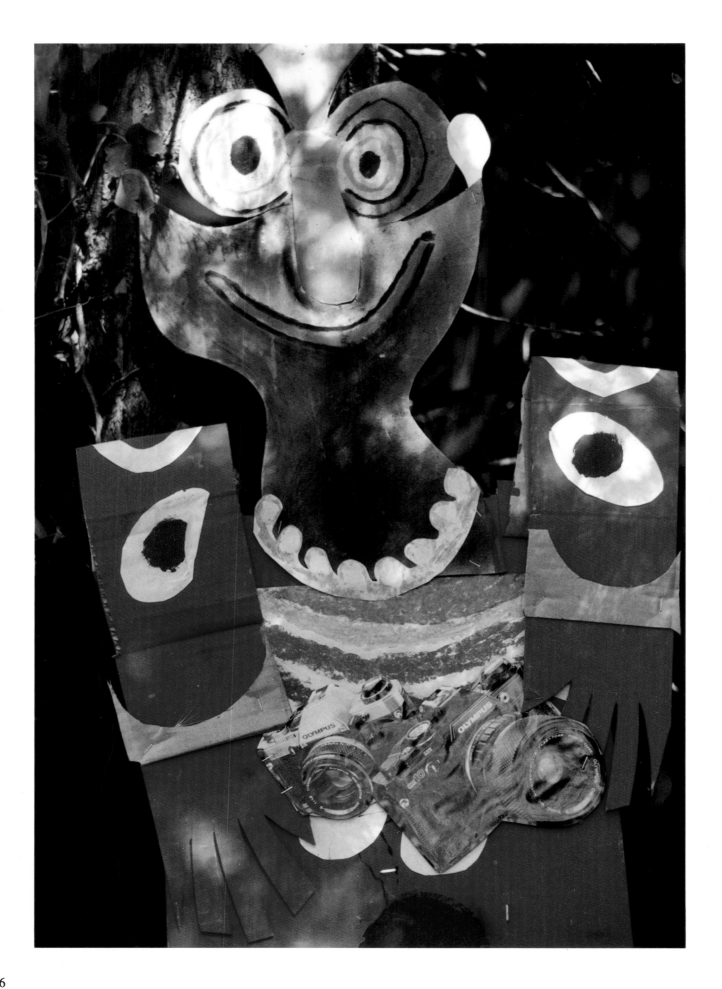

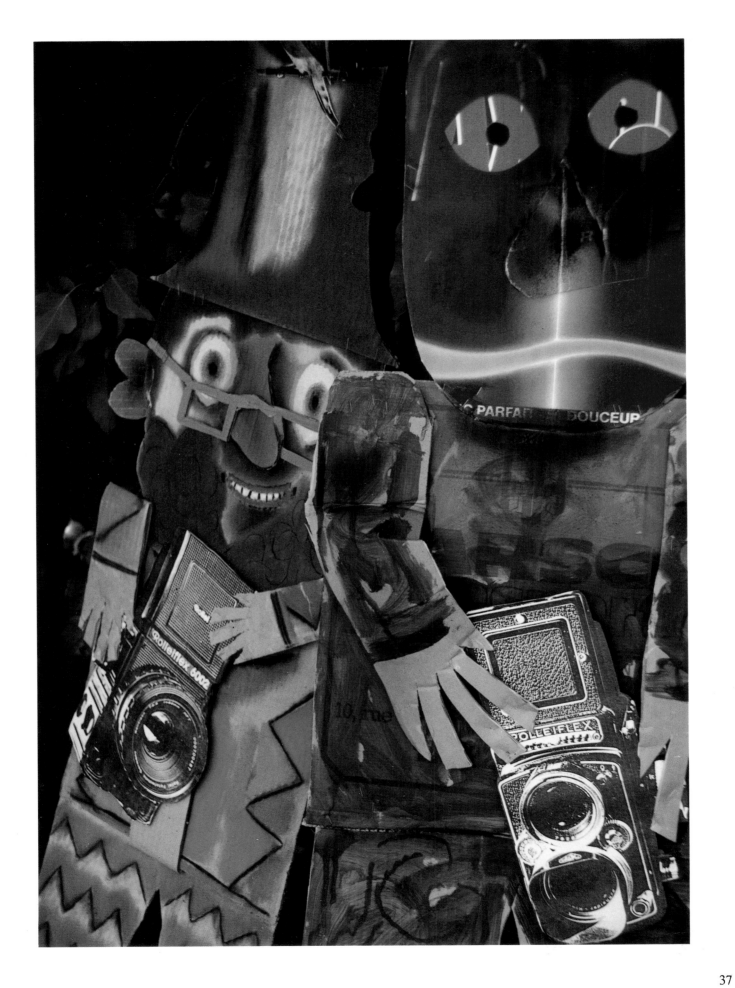

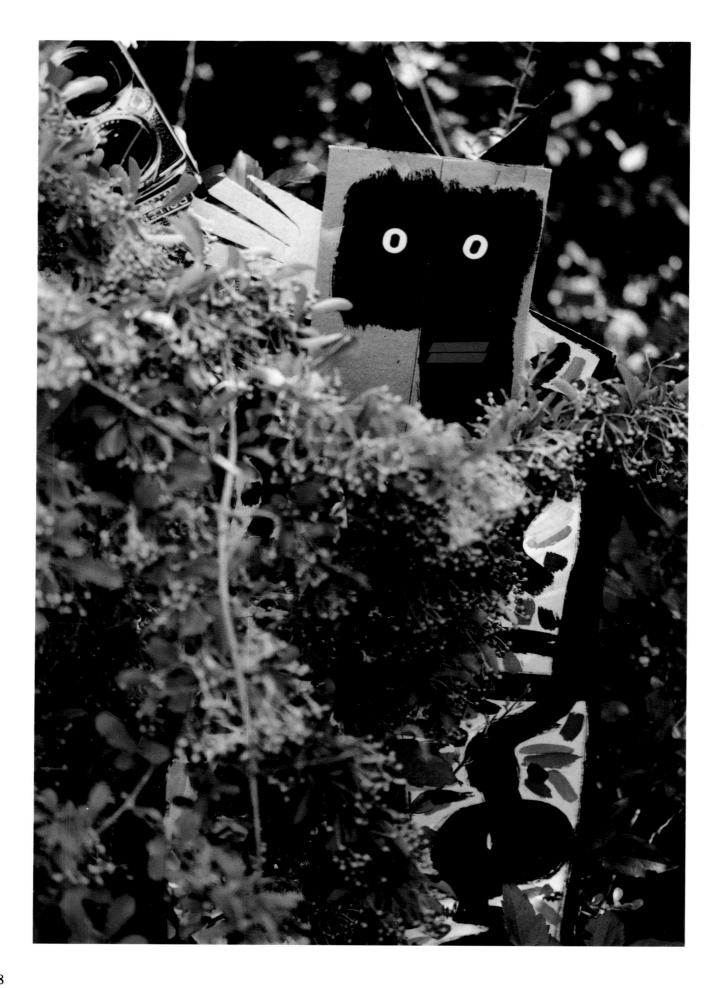

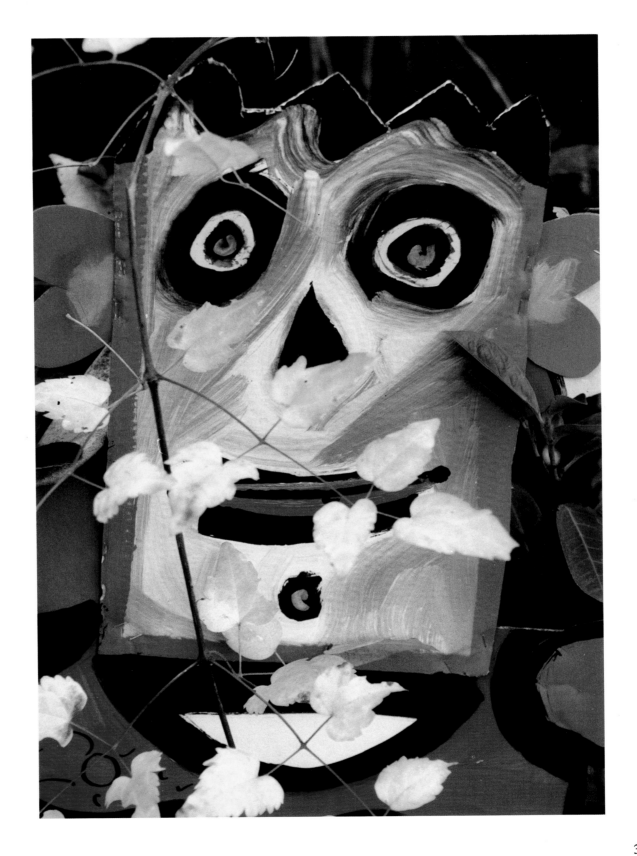

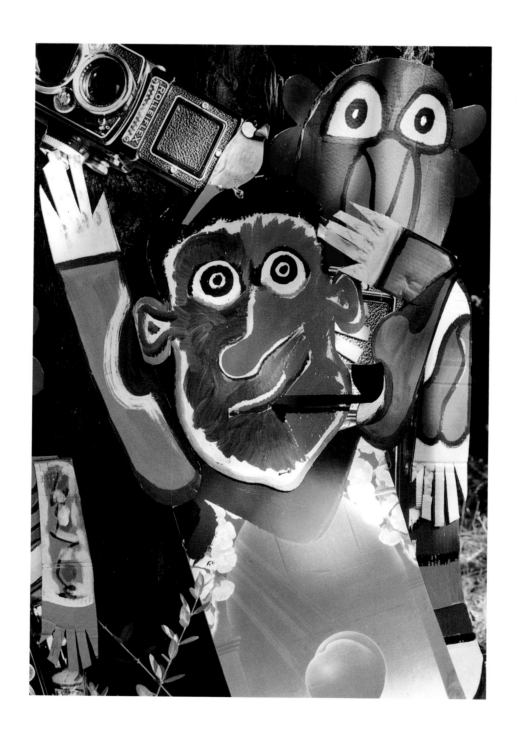

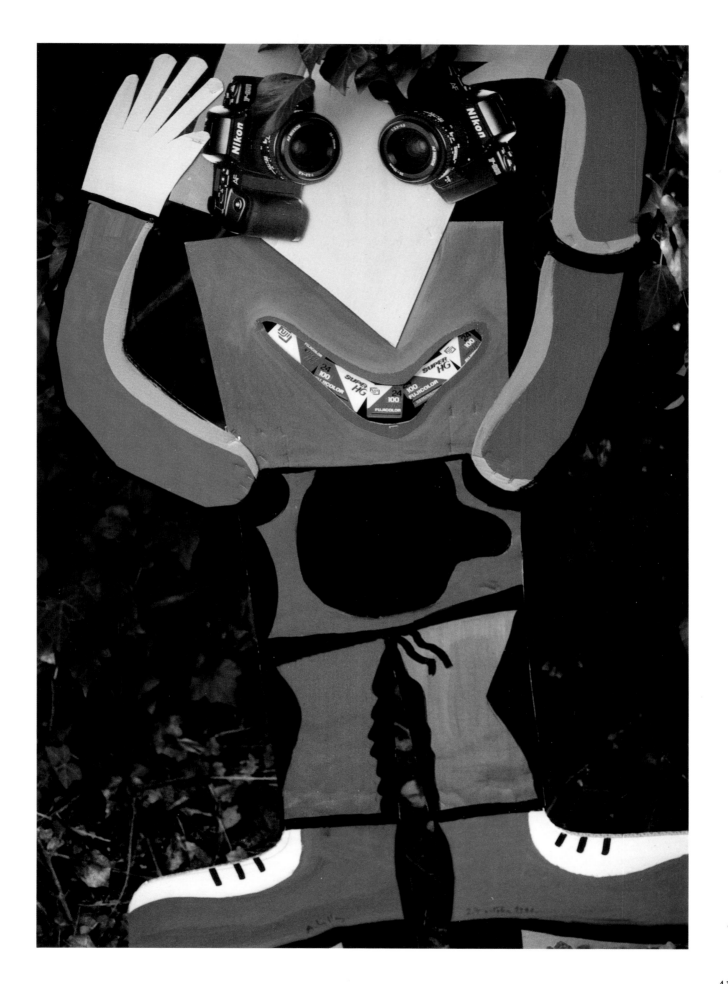

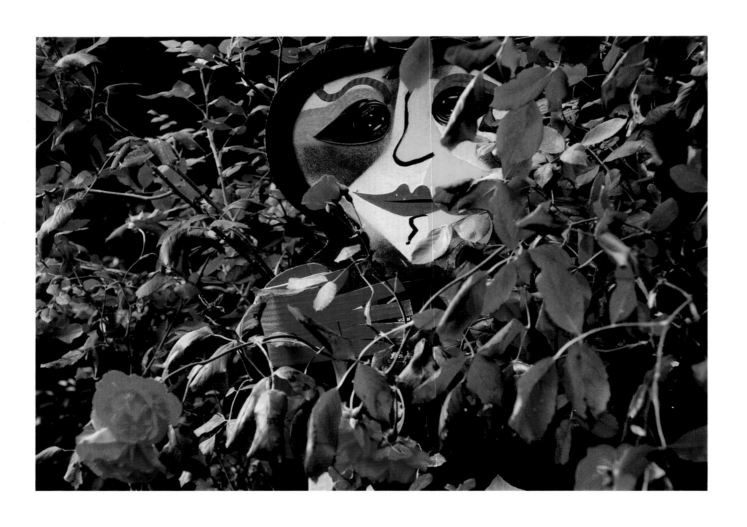

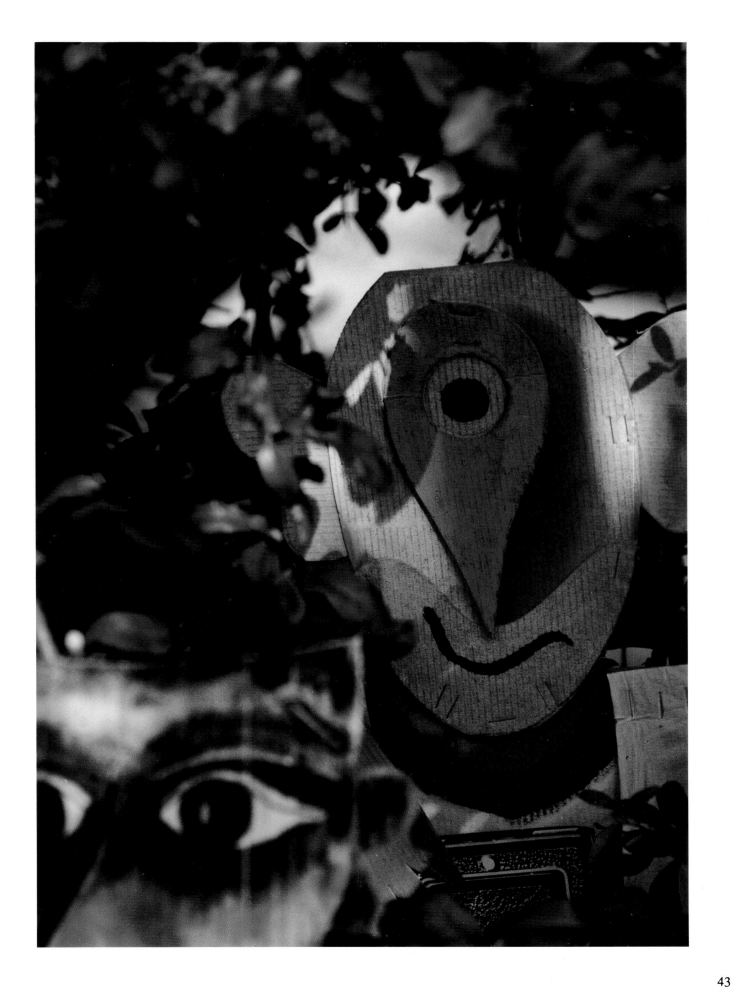

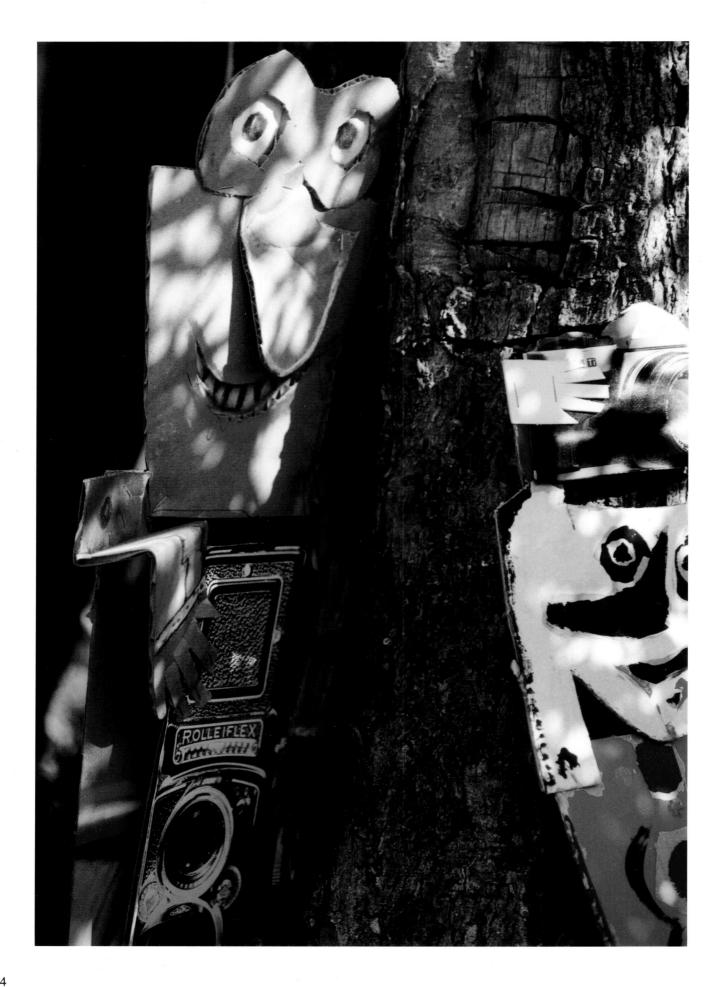

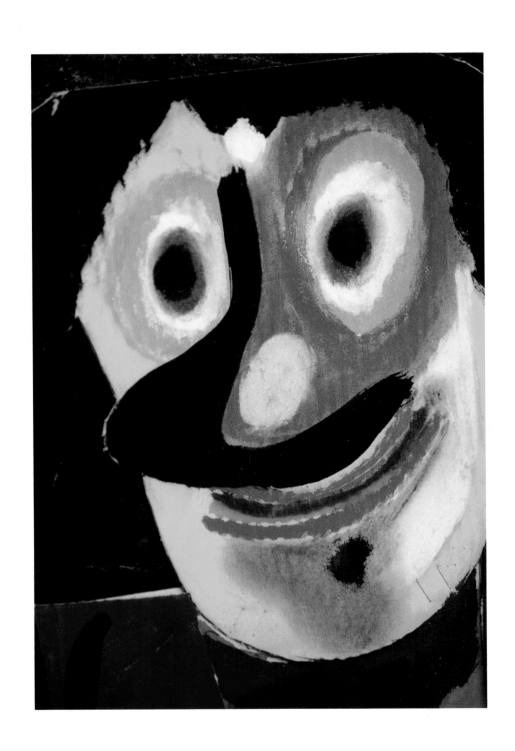

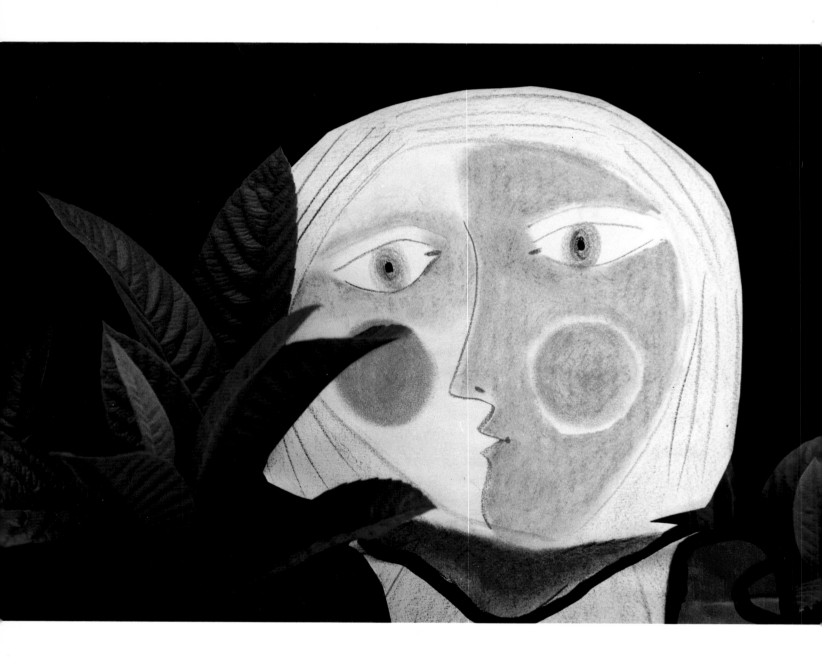

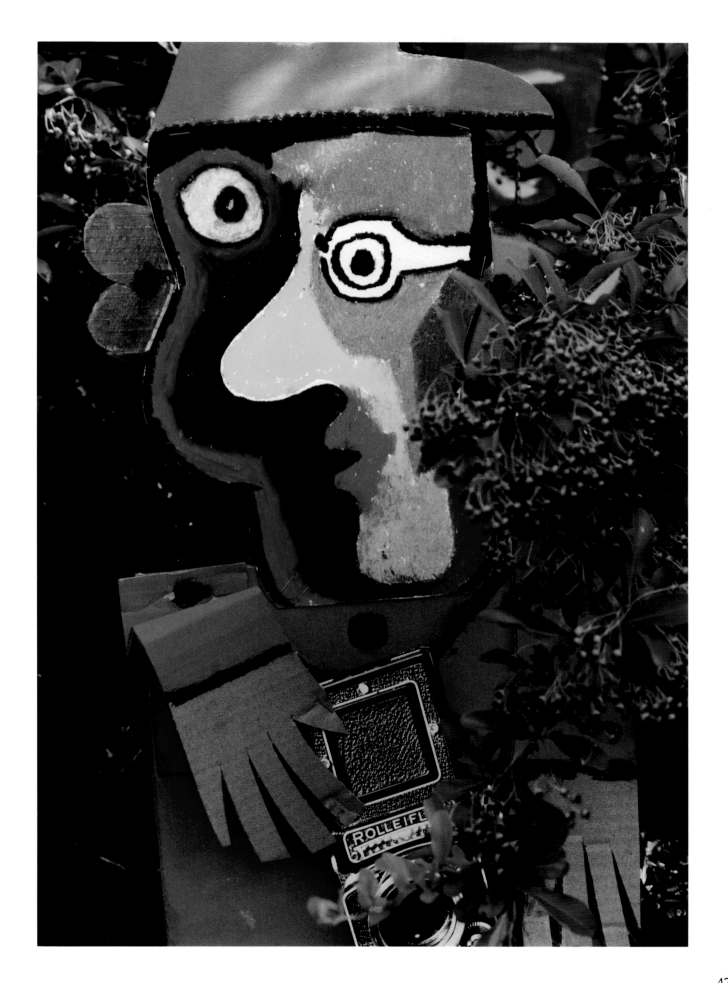

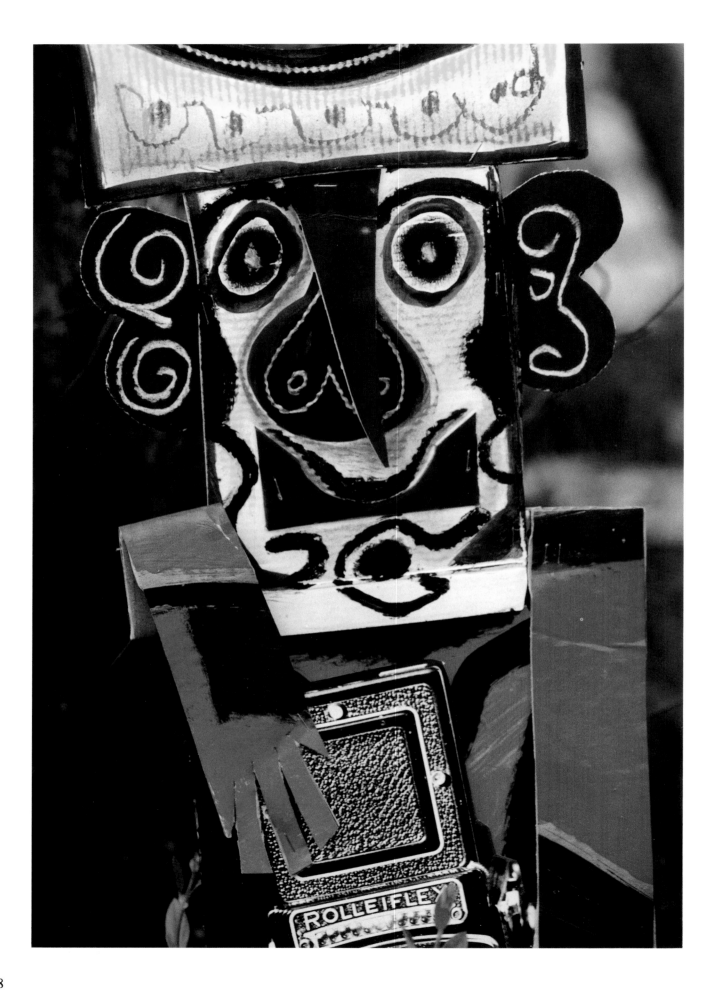

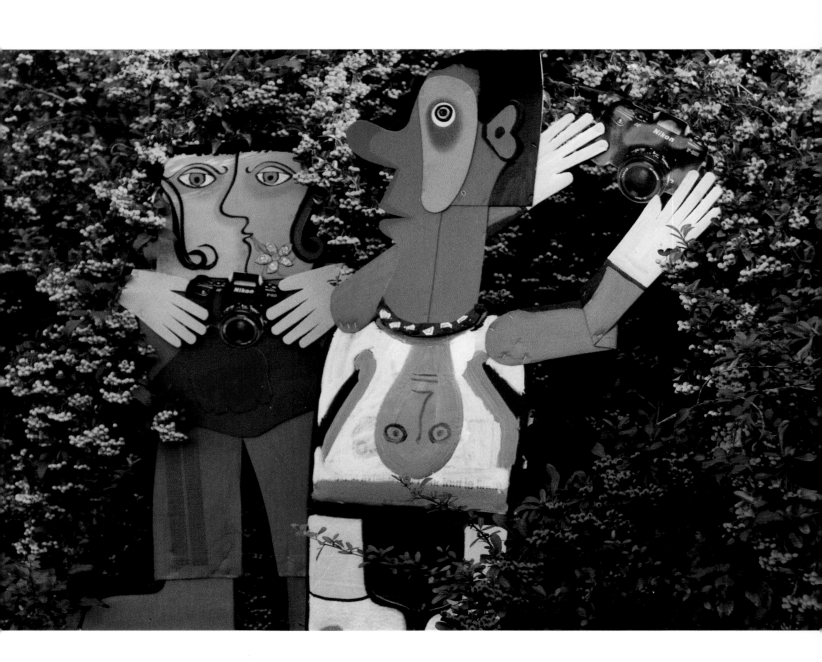

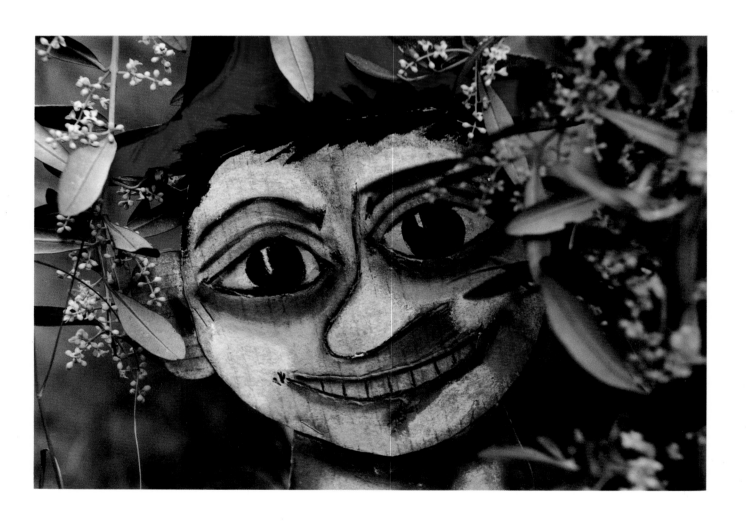

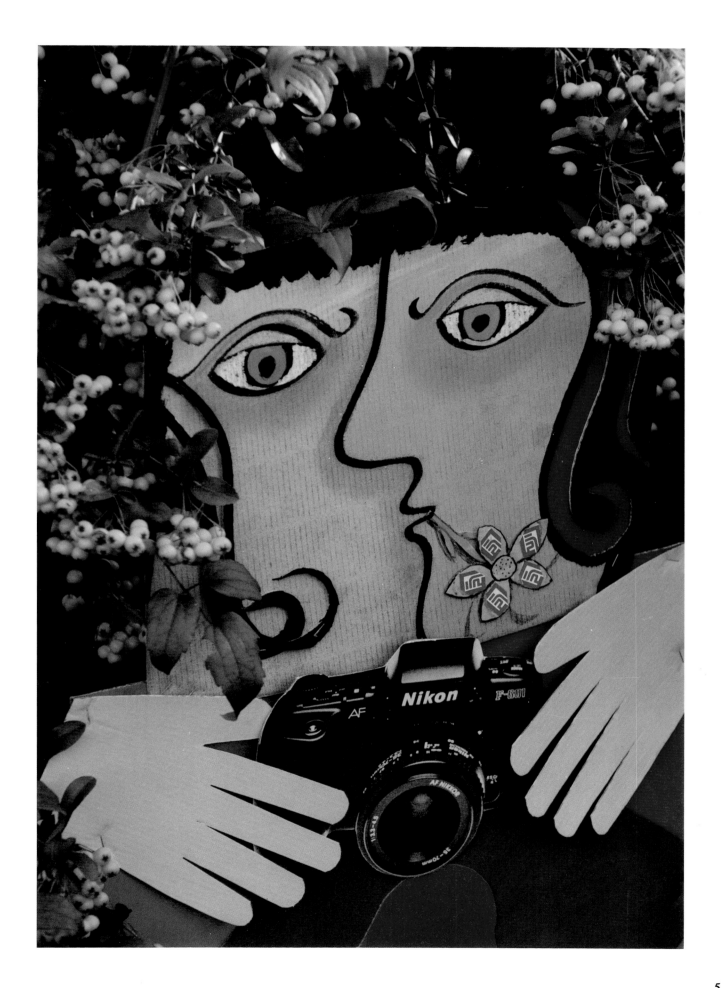

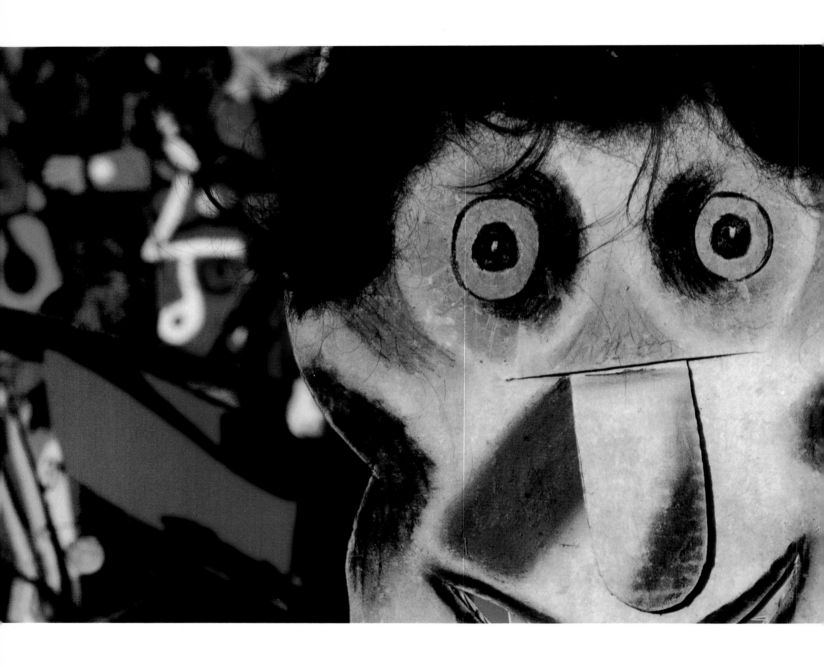

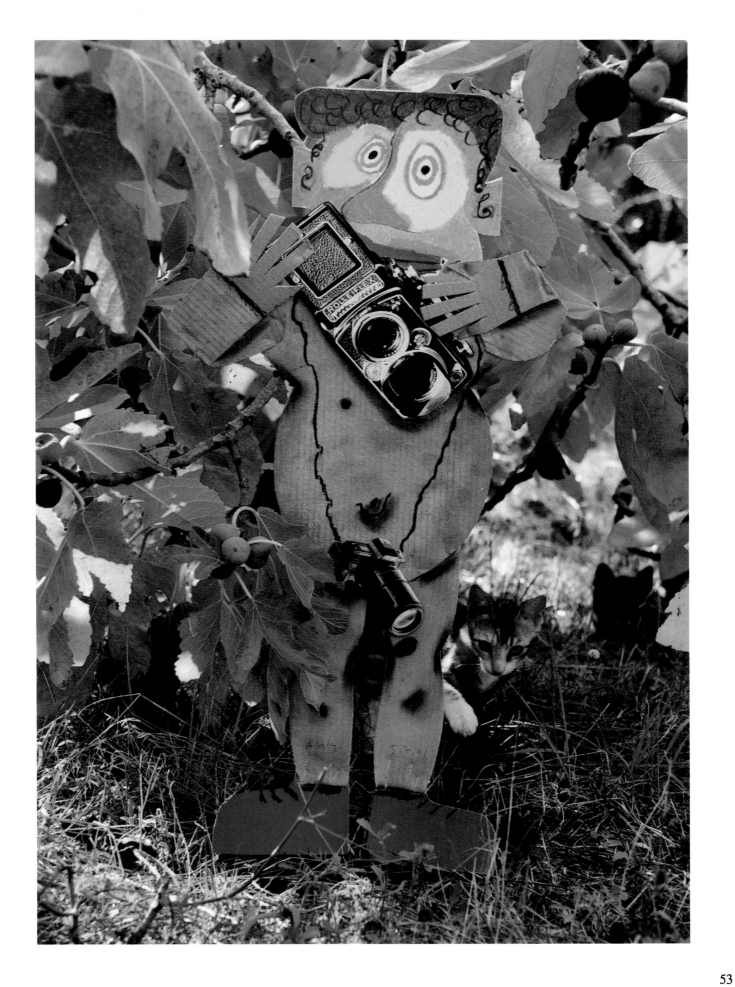

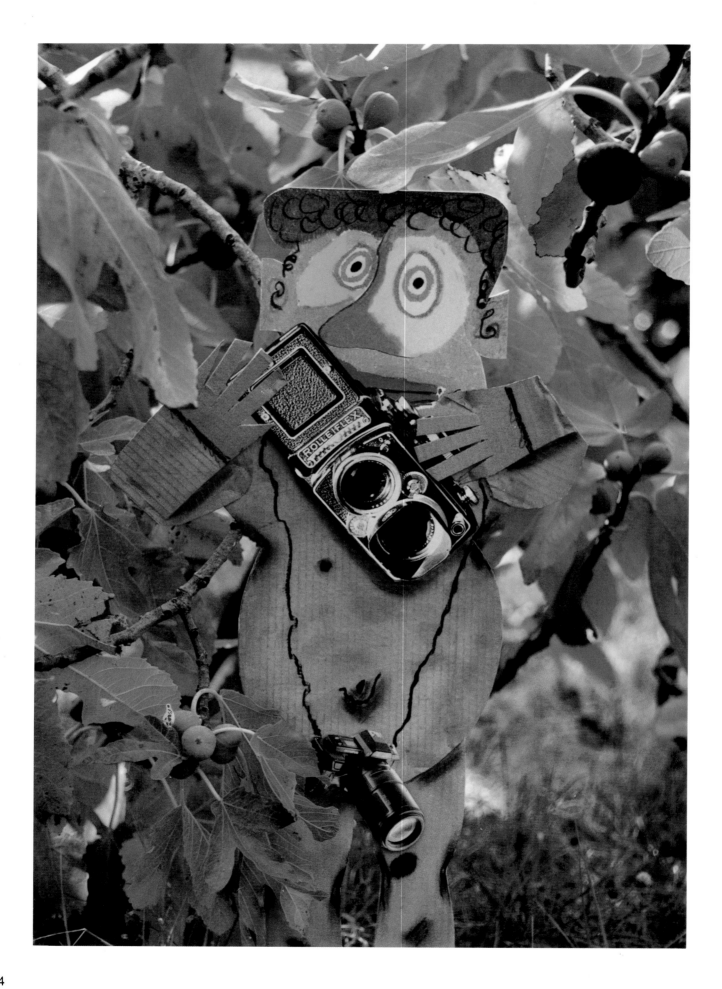

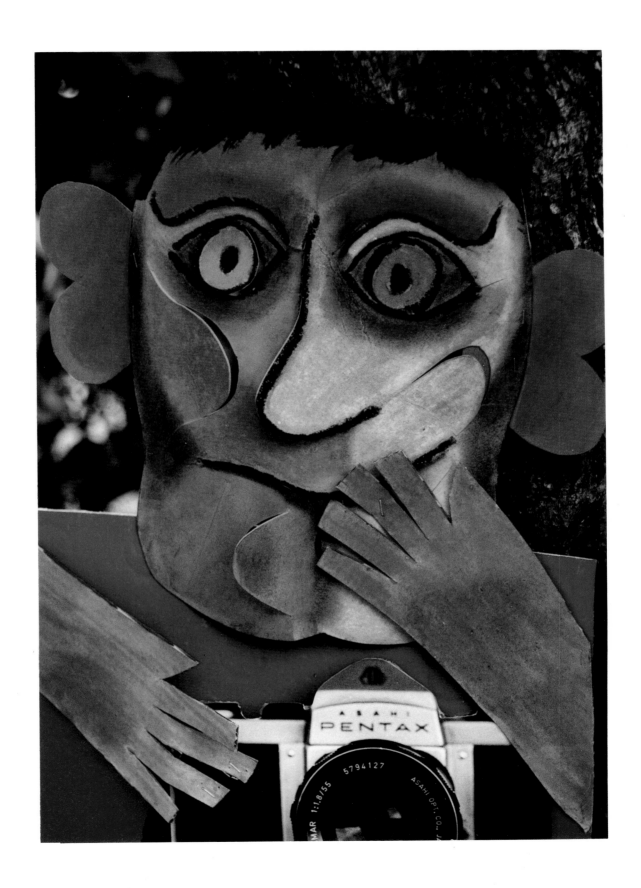

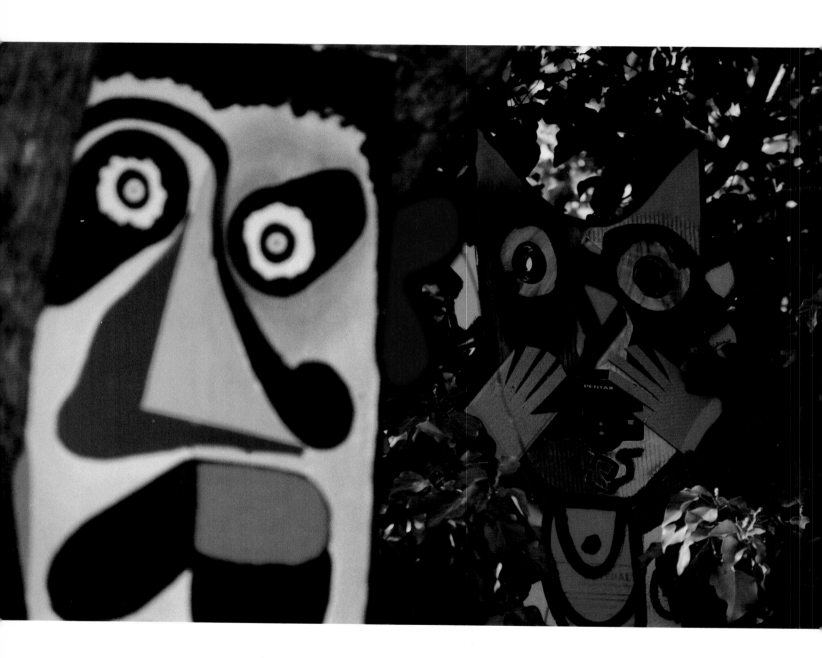

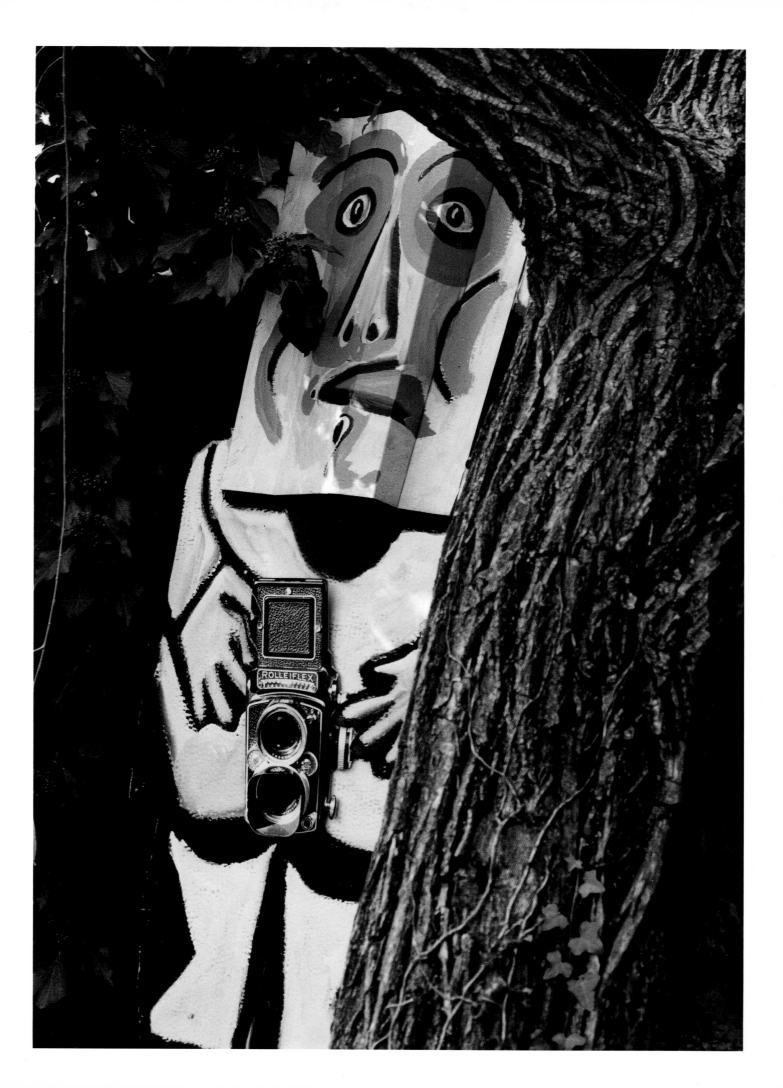

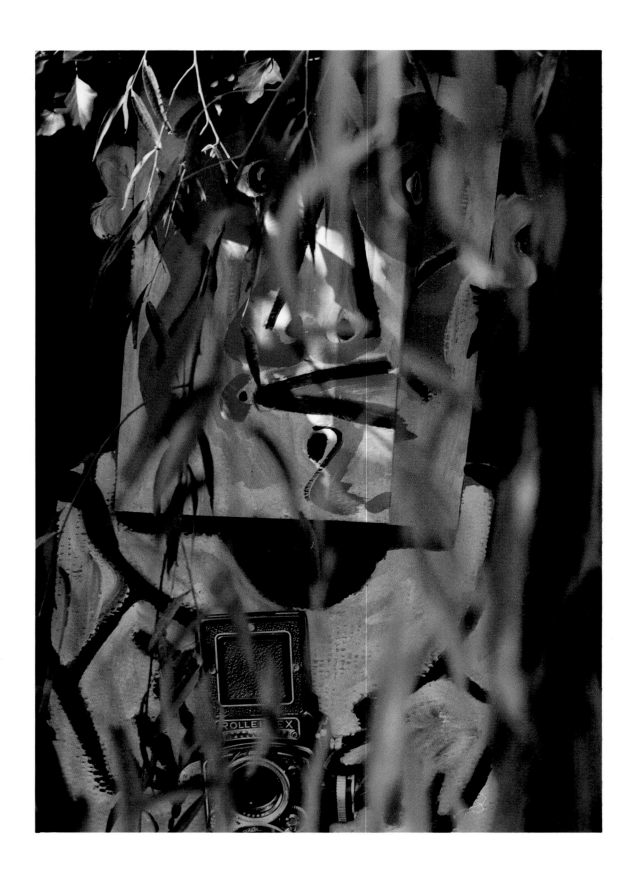

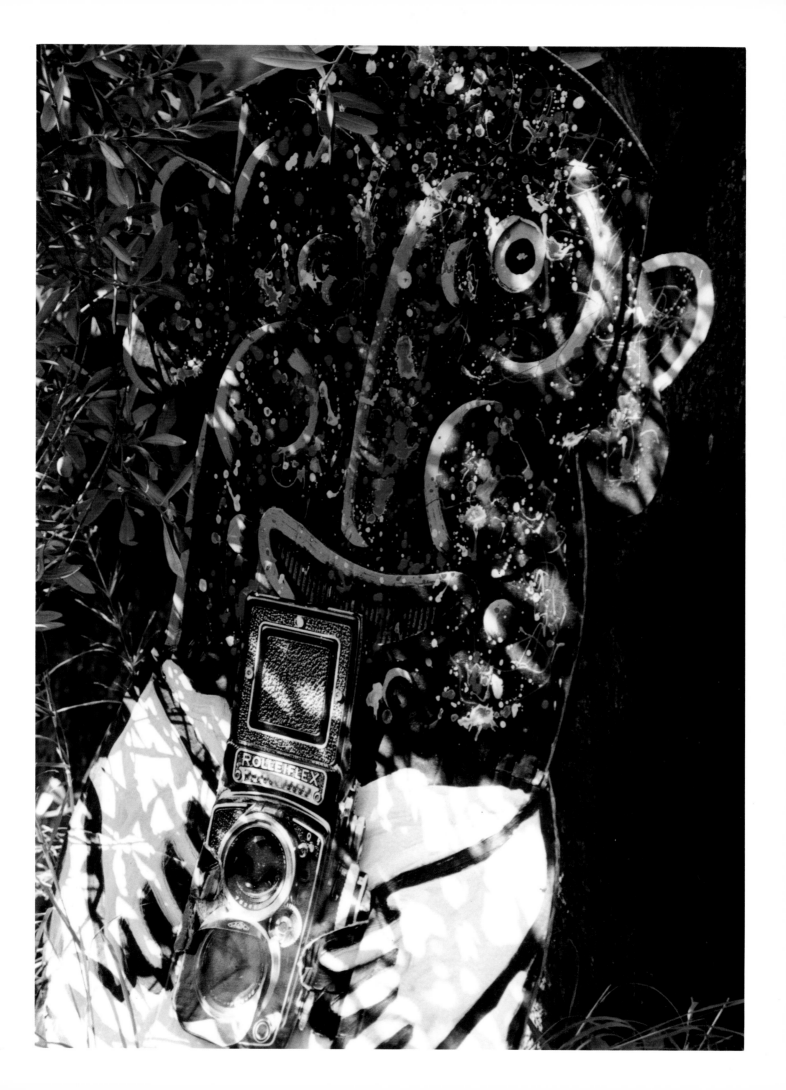

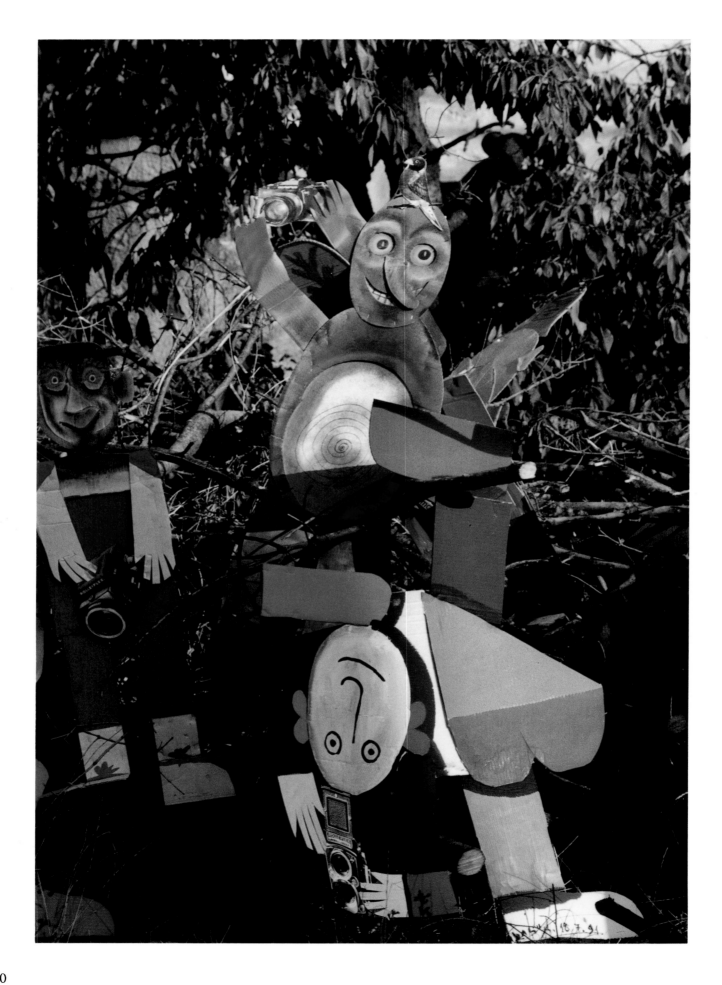

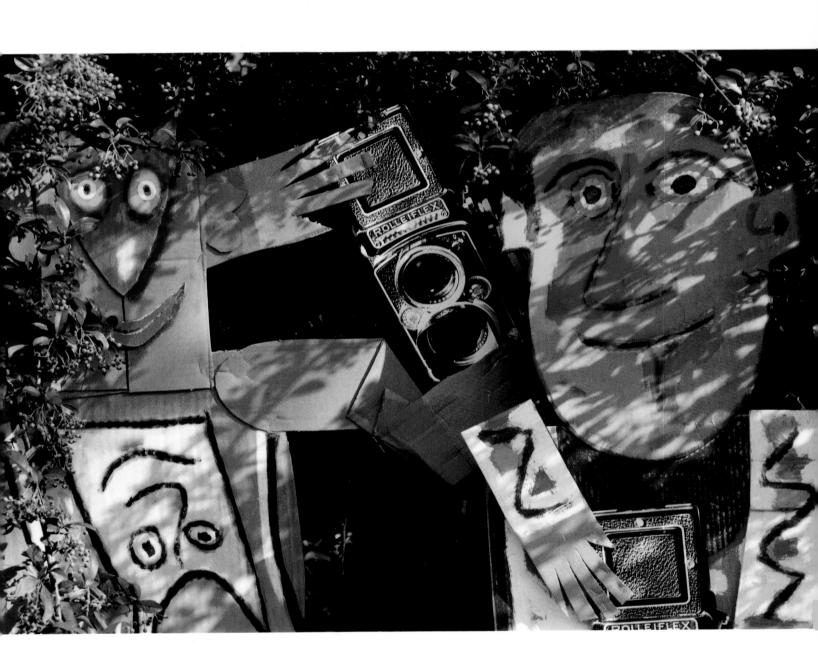

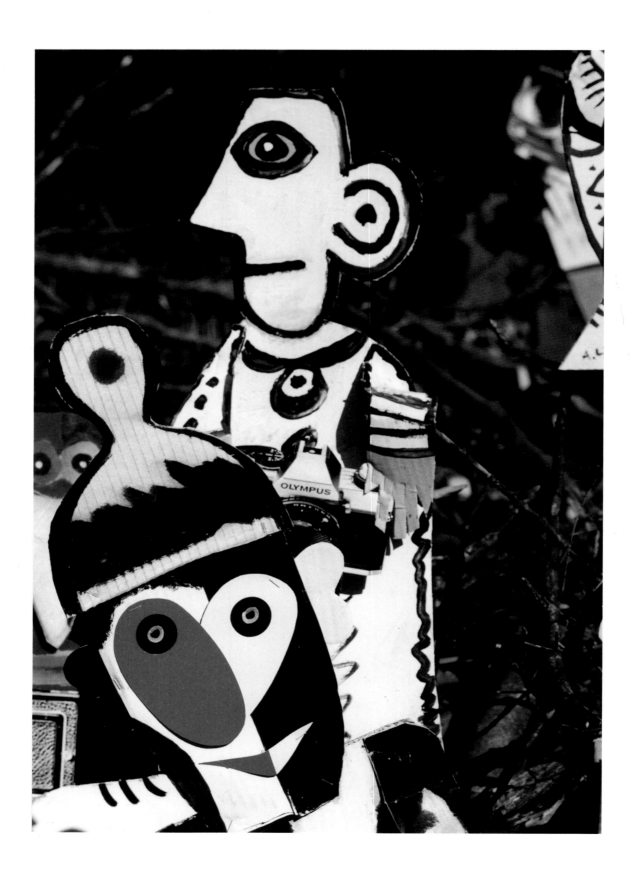

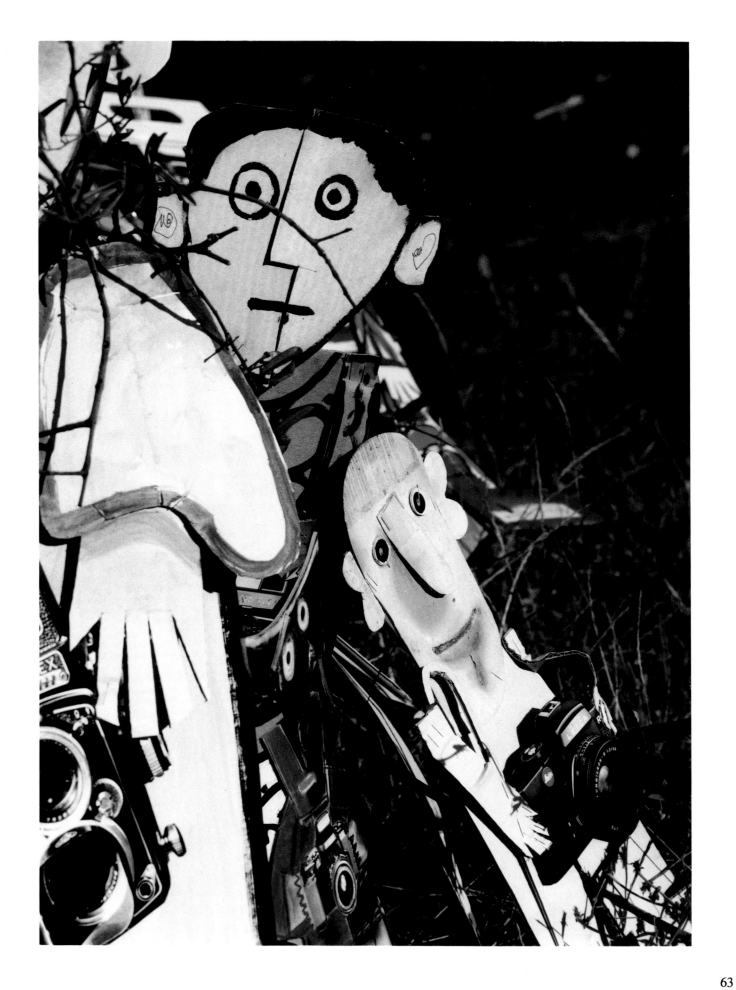

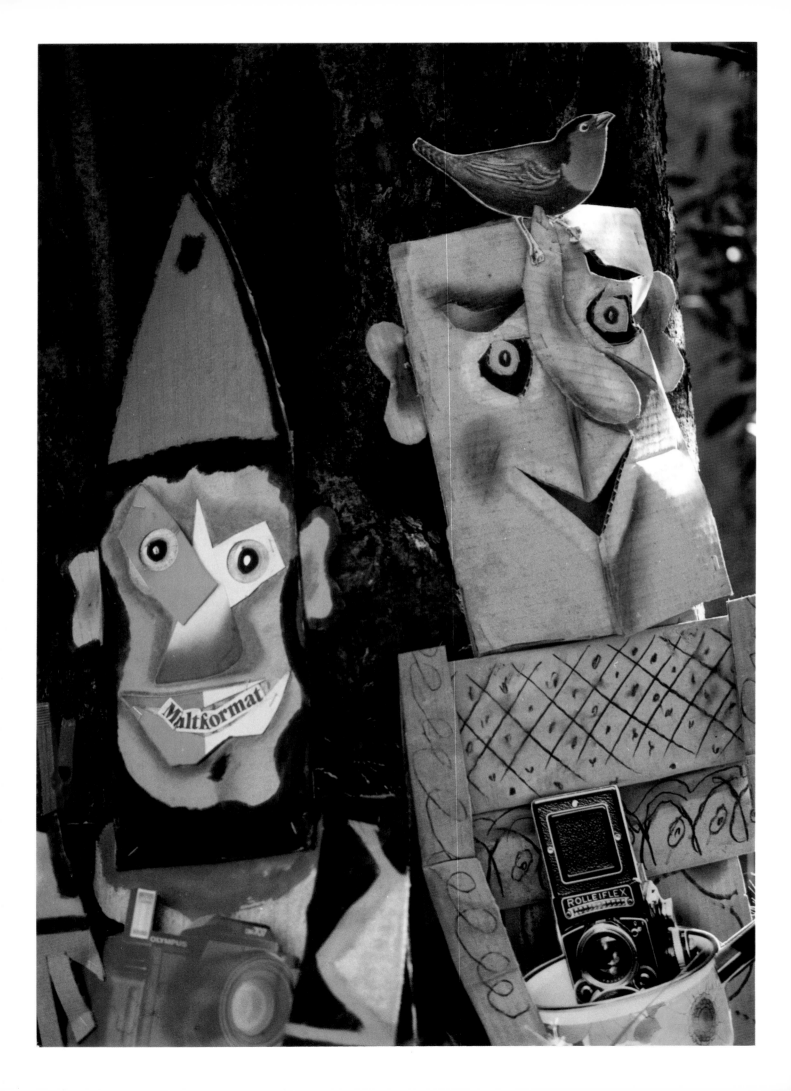

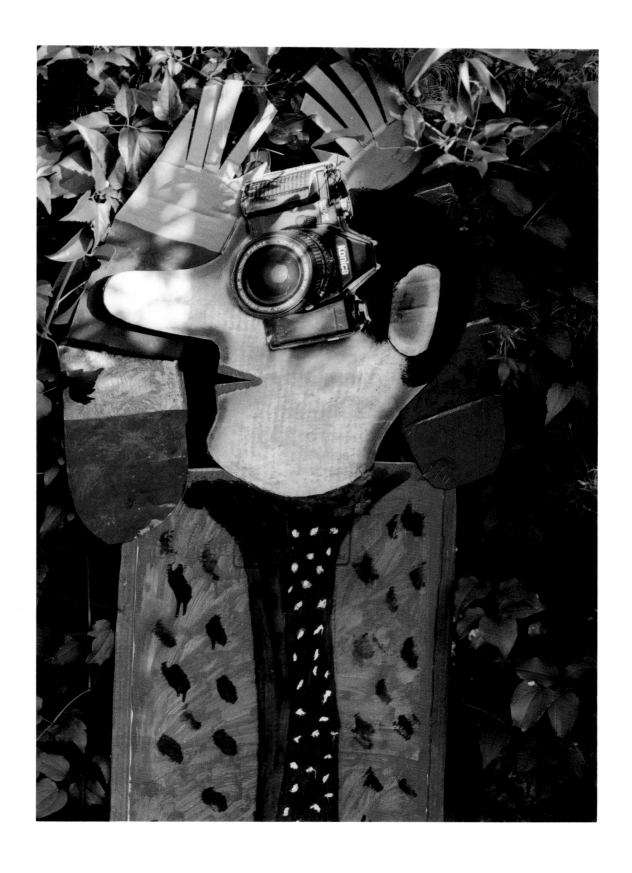

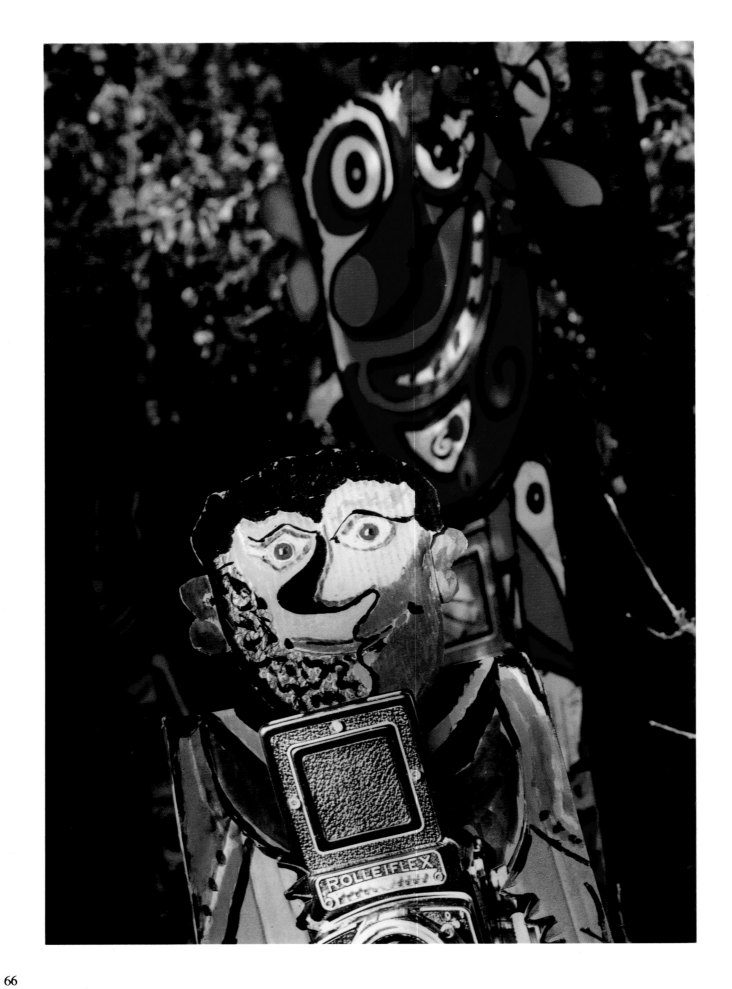

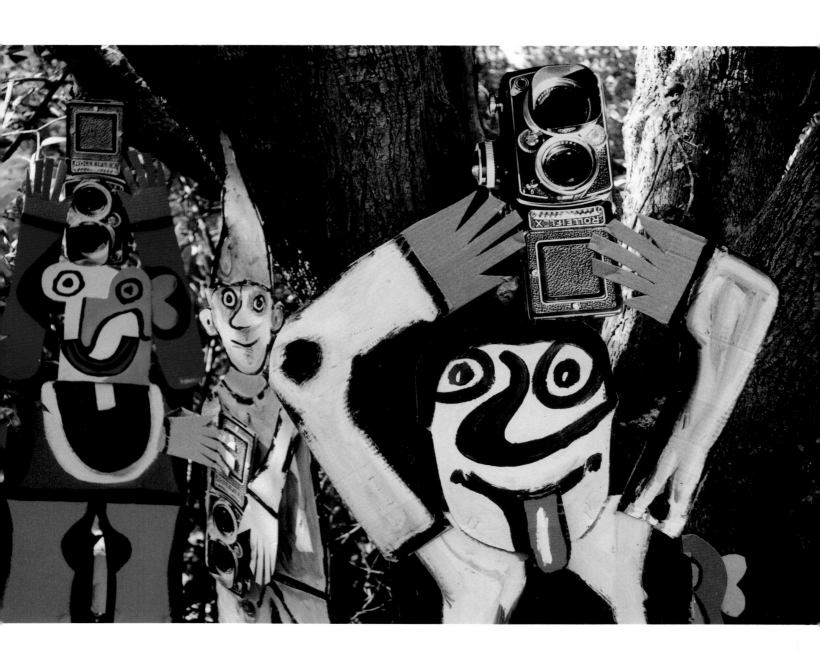

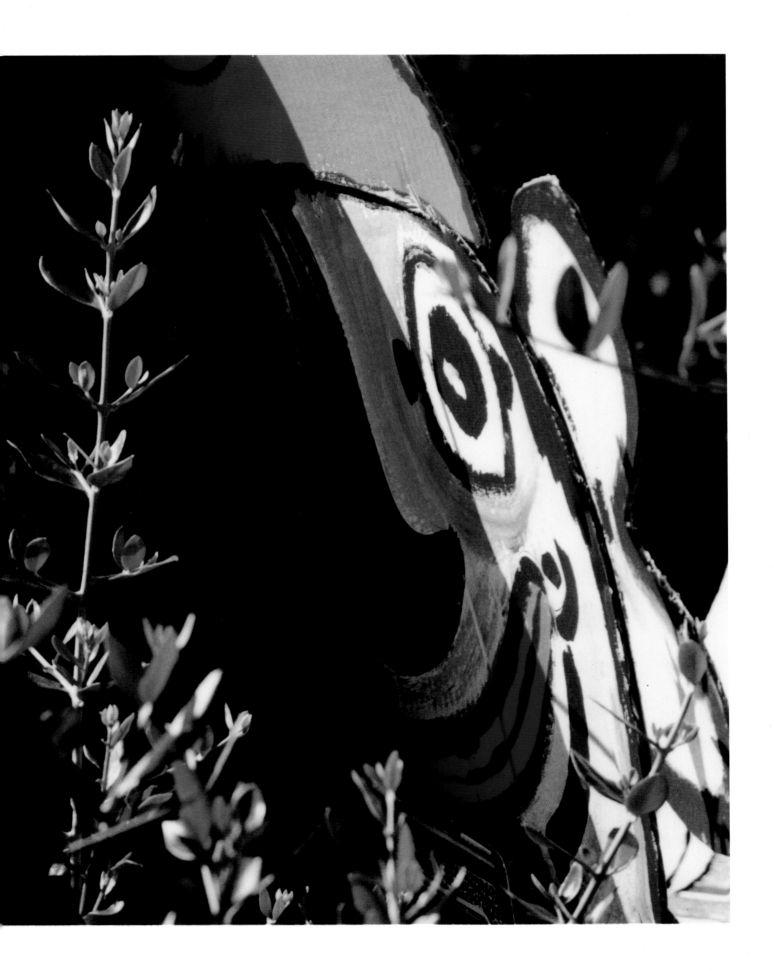

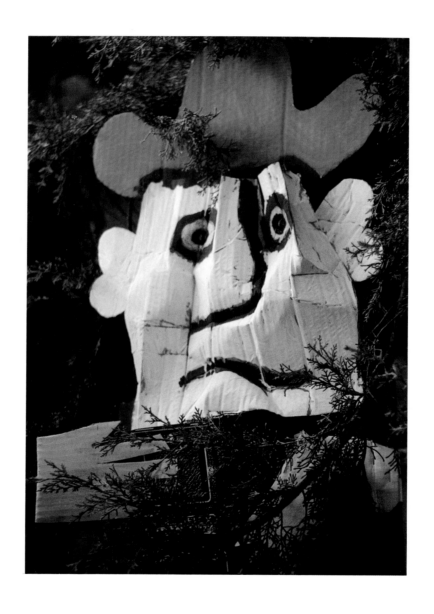

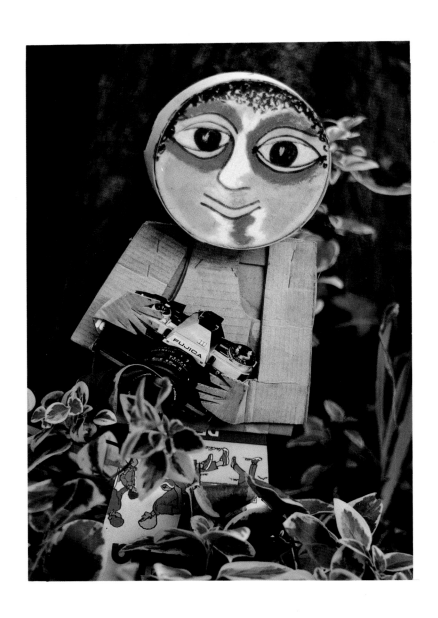

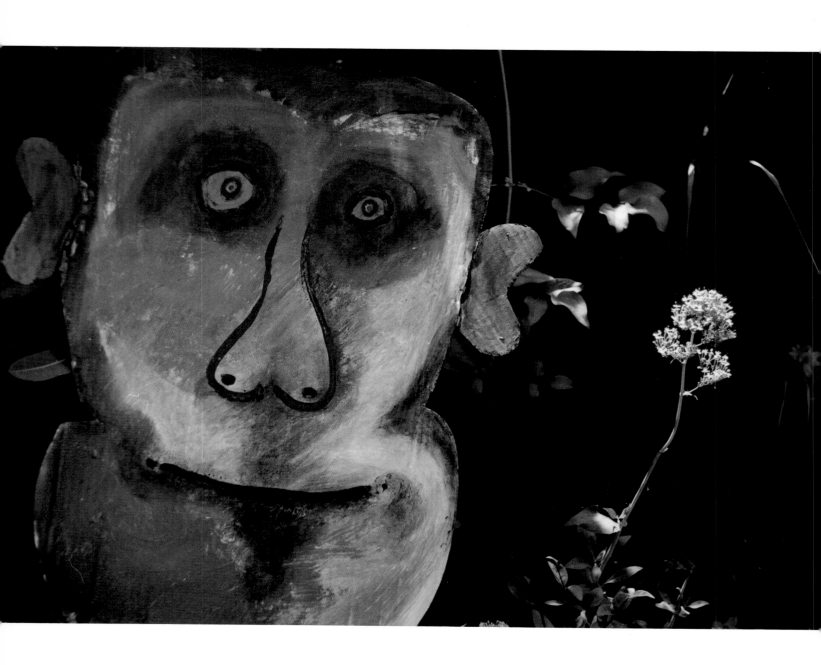

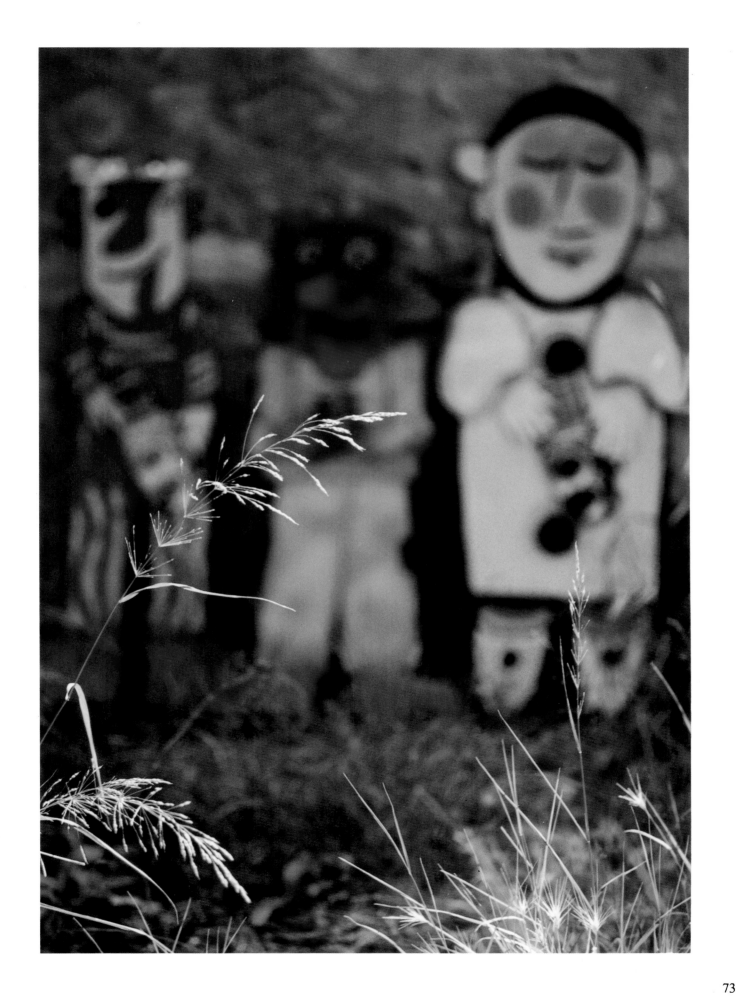

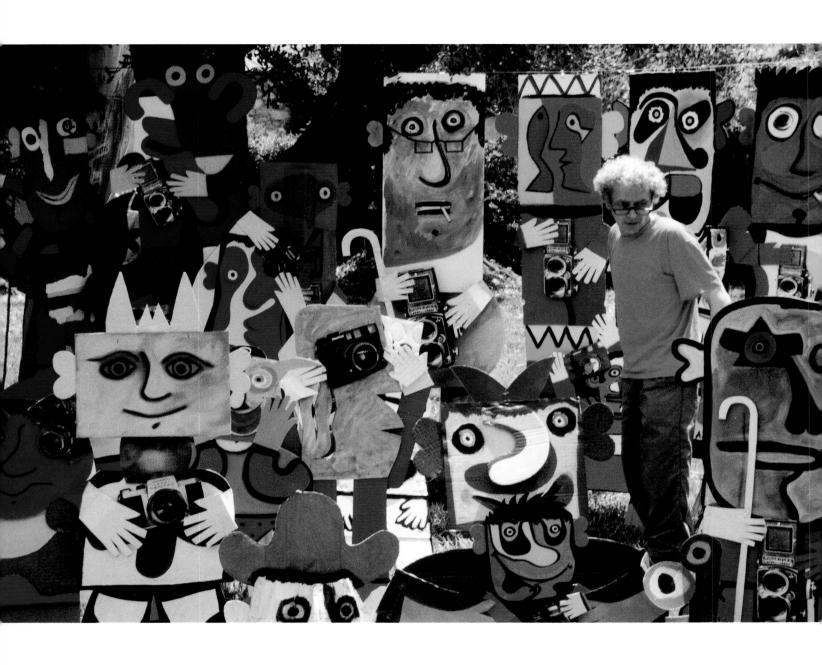

Dedicated
to
André
who recreated his world

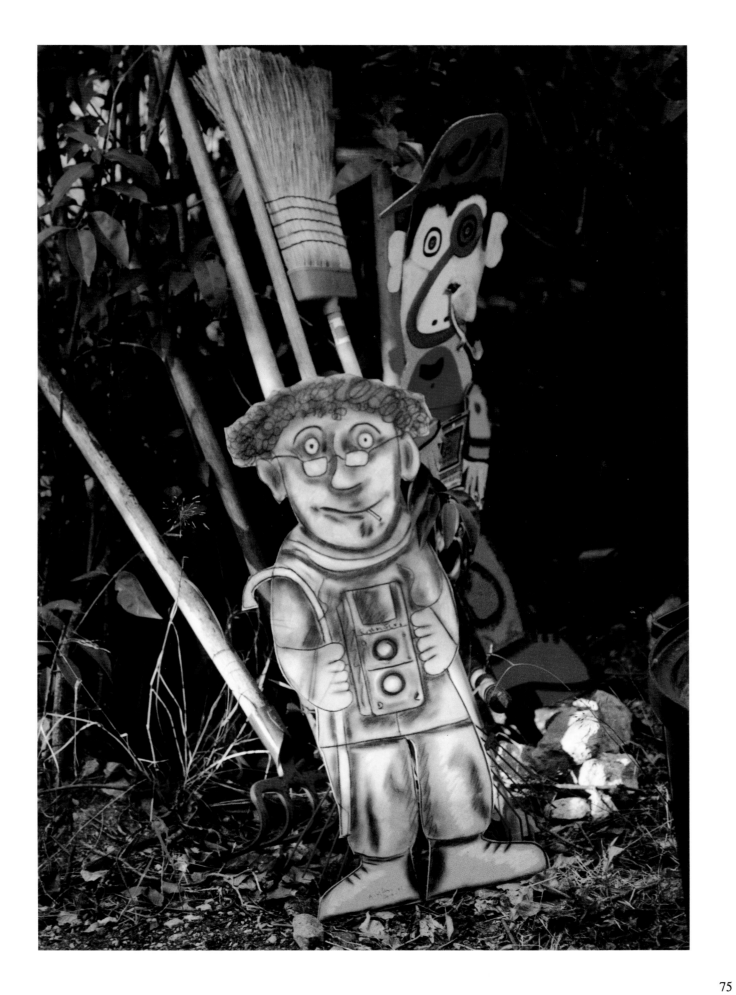

Postscript & Photo Data

Making this book was an escape from reality for me, a veteran war photographer who watched with frustration while instant-TV reported a world that I would have covered during those golden years when I was with LIFE magazine. Palestine, Greece, Korea, Indochina and other remote exotic lands then lay shattered by violence, which my LIFE colleagues and I tried to record forever. Without restraint or censorship. Competing for every page -- sometimes dangerously and even wildly -- against each other and our luck. I like to remember pages devoid of any bias: filled with panoramic picture essays on Man's evolution through religion and art; unlimited pages devoted to those first flights into outer space; countless pages made historic by images of searing compassion for the disinherited.

1991 was probably instant-TV's premium year for exploiting seemingly interminable unedited films of desert courage and carnage, collapsing empires, reborn dreams thought eternally stifled, and the faces of fallen heroes behind those often sullen masks of their victors. But then, at the end of the year, only a moment for that exhausted, battered face of Baron Gérard d'Aboville, a man who, alone, conquered the Pacific Ocean in a rowboat. Just a flash of bearded pride at the tortured end of a six-thousand mile voyage of self-imposed anguish to capture a dream. The screen blinked again -- he was already gone. And I wished that I might have shared the one hundred and thirty-four days of his terrible vision.

With my camera.

a Secret Garden is only one chapter in the story of another loner's romance with the unknown. But for him there is no limitless ocean or soaring peak to look back upon after its conquest. Nothing but stacks of colored cardboard that nobody noticed.

This is a captionless photo-diary of the many often silent months that André Villers shared with me during the past year. And there was rarely a time among all of those drama-drenched earlier years when my cameras served me better.

For *Secret Garden*, my camera was a Nikon FE fitted with Nikkor zoom lenses: 35-105mm or 70-210mm. All exposures were set on manual control, usually at 1/125 or at 1/250 second. Apertures averaged around F5.6, with many pictures taken in oblique evening light or shadows. Which brings me to the film.

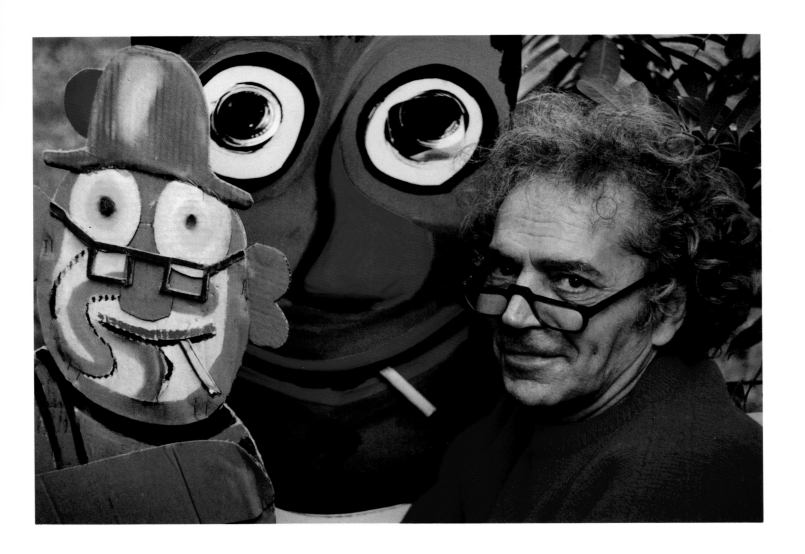

Everything was shot on Fuji 400 Super HG negative color film which I
was quite unfamiliar with until I started working in Villers' garden. It
was a surprise. When shooting in deep shade I could achieve both color
saturation and a sense of Villers' artistic passion that startled me -- and
everyone else who saw the first mock-up pages of this book. All film
processing was done by André Cuccia who operates a one-man, world-
class photo lab at the supermarket of Mougins, a village near my home.
He used Fuji SFA color paper and developed all films and prints in a
Fuji Minilab FA Compact unit, with neighborhood kids and parents and
foreign tourists milling around waiting for their snapshots while he
meticulously refined the results of my films in between.

This entire book was reproduced straight from color prints made by
Cuccia in his "One Hour" hole-in-the-wall shop. Last autumn, at the
Frankfurt International Book Fair, some of the finest color printers in
the world looked at my dummy of Villers' work -- and tipped their
professional hats to Cuccia .

So does André Villers, smiling in his secret garden.

D.D.D.

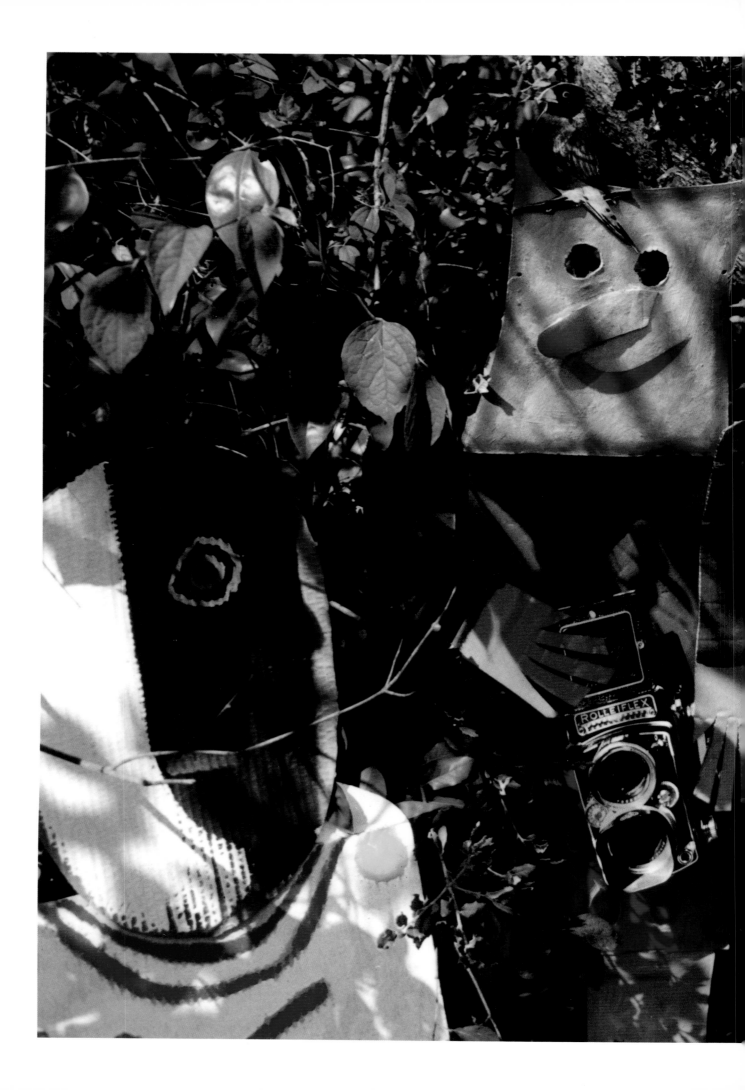

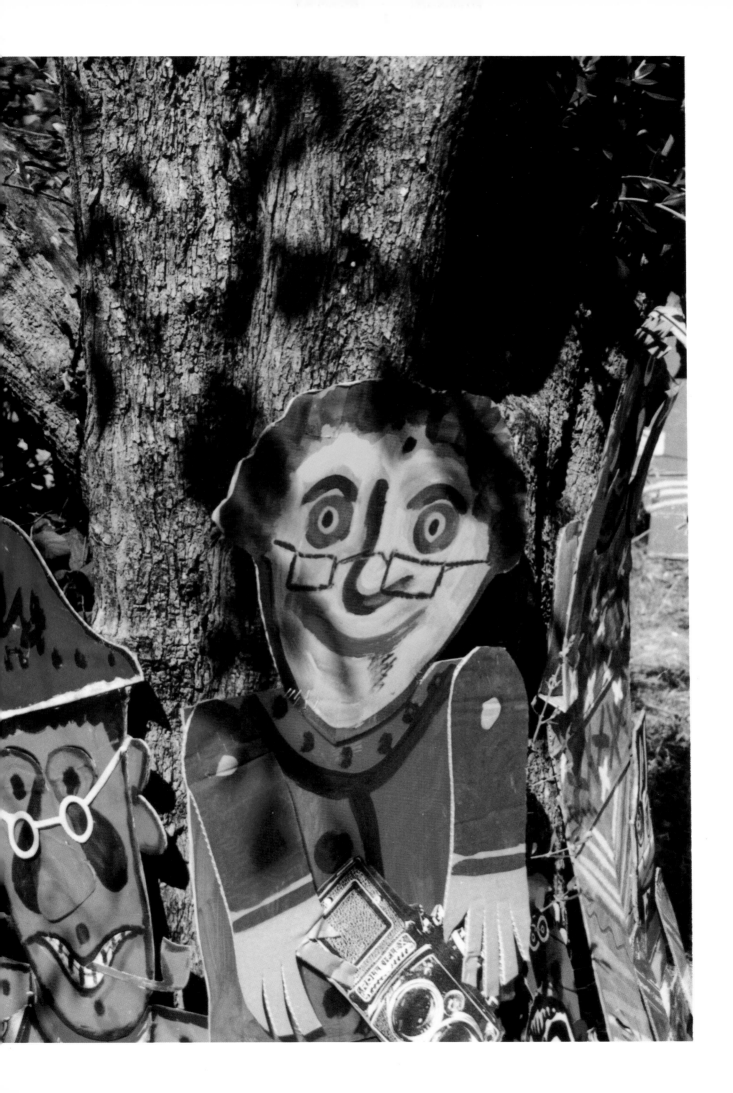

master color prints
André Cuccia
titles & text word processor
Kate Leconte
printing & binding
Dai Nippon/Tokyo
negative color film/paper/instant-printer
Fuji
photography/text/design/production/publisher
David Douglas Duncan